Images of Modern America

JIMMY CARTER IN PLAINS
THE PRESIDENTIAL HOMETOWN

D1319452

Images of Modern America

JIMMY CARTER IN PLAINS
THE PRESIDENTIAL HOMETOWN

ROBERT BUCCELLATO

ARCADIA
PUBLISHING

Published by Arcadia Publishing
Charleston, South Carolina

Printed in the United States of America

Library of Congress Control Number: 2015953871

For all general information, please contact Arcadia Publishing:
Telephone 843-853-2070
Fax 843-853-0044
E-mail sales@arcadiapublishing.com
For customer service and orders:
Toll-Free 1-888-313-2665

Visit us on the Internet at www.arcadiapublishing.com

To Steph, Mom, and Grandpa for those first trips to Plains

CONTENTS

ACKNOWLEDGMENTS

This book has been a dream of mine for years, and it would not have been possible without the efforts of Charles Plant and Eddie Hunter. Special thanks to my family and friends, my wife, Stephanie, for her love and support, President and Mrs. Carter, the outstanding staff members of the Jimmy Carter National Historic Site, and the town of Plains.

I would also like to thank Vice President Mondale, various Carter administration officials, Richard Hyatt, Phil Wise, and Betty Pope for their generous interviews. The girls at work have humored stories of Plains for years now. To Bubba, you are deeply missed, and Anita, holler when you see land.

Unless otherwise noted, the images in this book appear courtesy of the Gerald R. Ford Presidential Library (GRF), the Library of Congress (LC), the Jimmy Carter Presidential Library (JCL), the Jimmy Carter National Historic Site (JCNH), the original photographs of Charles W. Plant (Charles W. Plant), and the author's collection (AC).

INTRODUCTION

Each time you travel to this lovely small town, you feel the strangest sensation take hold. The mind wanders across images and moments of one's youth. It seems impossible for nostalgia not to take hold. Once you enter the block of buildings that make up the business district, the importance of the location becomes apparent. Often, its welcoming set of curved parking spots are the first port of call for many sightseers that flock to the town. Its unique and still-functioning shops remain local hubs of activity for the community. Yes, you can purchase a can of Billy Beer here, but, you can also get a cup of coffee and interact with friends. This is where the old Carter Warehouse was located, where President Carter's uncle used to sell antiques, and it is the site of Plains' sole inn—perhaps the only one in the nation where a former president built most of the furniture.

There is a historical pull to this place, manifested in the tiny, green-and-white-painted train depot at the center of town. For myself, this humble structure has always held such romantic attachment. This was where Jimmy Carter pulled it off—where he, along with his neighbors and family, staged the most improbable and captivating presidential campaign in history, forever changing the political landscape of the nation and how we pick our presidential nominees.

As one enters the depot, long devoid of frequent activity, a single video can be heard echoing throughout the building. It is a video that Charles Plant put together about the 1976 election. The images are old, and the voices heard are those that use to fill the television screens in countless homes decades earlier. The nightly news anchors of the past—Walter Cronkite, Harry Reasoner, and John Chancellor—can be heard. The desired effect is easily achieved, transporting visitors to a time when this depot was packed with locals and campaign workers, when primary nights would turn into local vigils and tailgate festivals. Several televisions were installed to witness the results of so many past contests, when the residents' favorite son was trying to achieve the impossible. Still seen in the depot are two rocking chairs, used frequently by America's First Mother, Lillian Carter. Today, a sign proudly and humorously recounts the fact that "Behind this closed door" is the reason the depot was selected as the campaign headquarters. It was the location of the only available public bathroom in town. Today, the bathroom is closed, and visitors are prevented from entering this historic lavatory.

As the election of Jimmy Carter became a real possibility, both the candidate and his hometown started becoming big business. Carter's wide smile began showing up everywhere, and souvenir makers had a field day turning the town into a household name. Some, like the N.G. Slater campaign buttons, were of high quality, while others were simply made by an endless series of small entrepreneurs looking for an easy buck. Eventually, the massive number of outside guests began to die down. When the Carter presidency entered the history books, the town and its famous son both shared in parallel struggles to acclimate to life outside the national spotlight. Plains and Carter both took it upon themselves to help preserve the best elements of the 1976 election and its aftermath for posterity. It was not an easy task for either of them. But President Carter threw himself into the task of turning key structures of his hometown into a national

park. With the aid of residents and outside supporters, the former president succeeded beyond his wildest hopes.

One

JIMMY WHO?

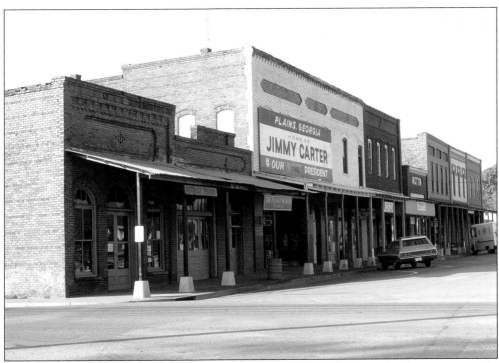

It was often proclaimed throughout the 1976 election that "The strength of one man can be measured by the path he takes to travel there." In the life of the nation's 39th president, all roads, no matter how elevated, seem connected to one small hamlet in southern Georgia. No town has ever been so rooted in the life and success of a president. (Charles W. Plant.)

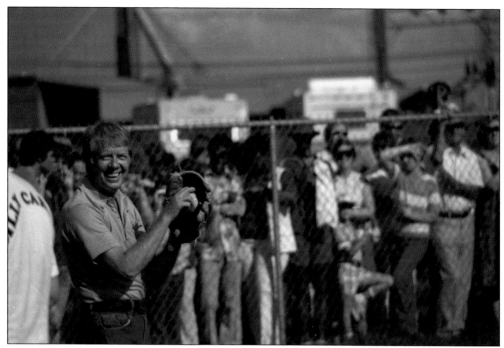

James Earl Carter made history from the very beginning, becoming the first American president born in a hospital, the local Wise Sanatorium. His mother, Lillian, worked there as a registered nurse. It was obvious to everyone in the small boomtown of Plains that this young man was different. The Carter family was always prosperous. Their farm produced cotton, corn, watermelons, and, of course, peanuts. (LC.)

The Carter boyhood home, two miles west of Plains, was, for years, maintained as a working farm. It was still privately owned during Carter's presidency. Not open to the public, it was visible from the road and was frequently a highlight for sightseers. (LC.)

As a child, Jimmy (seen here kicking a football) was free to play with the African American children raised in Archery and Plains. His father, James Earl, was a successful farmer, local public official, and staunch conservative Democrat. James's wife, Lillian, did not share his views on race and was much more liberal on civil rights. Many times, James would leave the house when she welcomed black guests. (JCNH.)

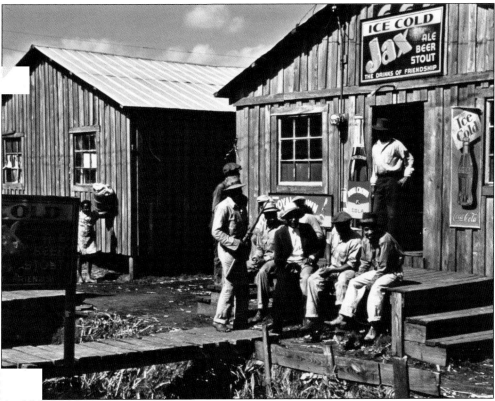

Like so many other areas in the country, Plains was ravaged financially by the Great Depression. Black families were particularly affected. Some journalists in 1976 were shocked to witness the level of poverty some African American families were living under and how close their dwellings were to the potential Democratic nominee's residence. (AC.)

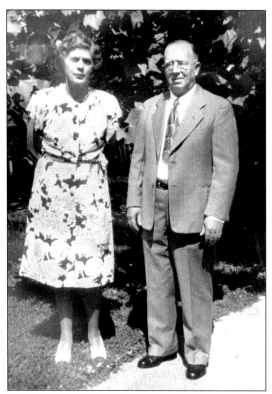

Plains remained unchanged throughout the 1930s and 1940s. Jimmy Carter graduated from Annapolis Naval Academy and married Rosalynn Smith. Soon, the young couple left Georgia to begin a promising life in the Navy. But following the untimely death of Jimmy's father, James Earl Carter Sr. (seen here with his wife, Lillian), the future president surprisingly gave up his naval commission and returned home to Plains. (JCNH.)

Apartment 9-A served as the home of Jimmy and Rosalynn Carter and their three sons, Jack, Chip, and Jeff, when they returned home to Plains in 1953. For over a year, they lived in this government housing unit while Jimmy Carter attempted to rebuild his father's peanut business. They remain America's only First Family to have lived in government housing. (LC.)

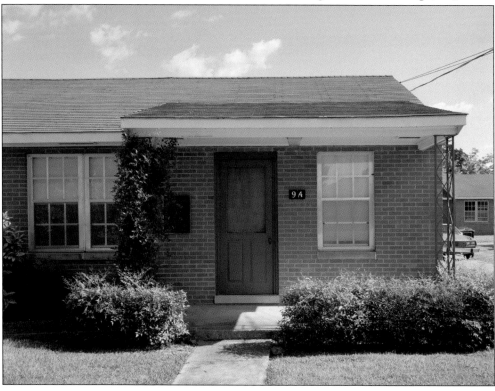

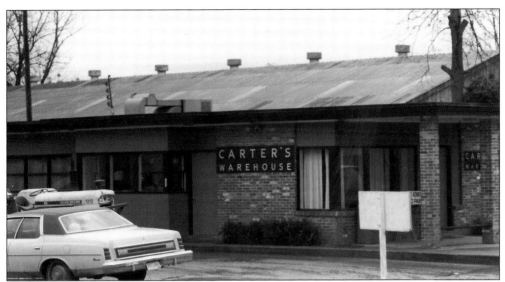

The Plain Peanut Store is located under the sign reading "Plains, Georgia, home of Jimmy Carter" (see page 9). This building was the warehouse of President Carter's father's peanut business. (Eddie Hunter.)

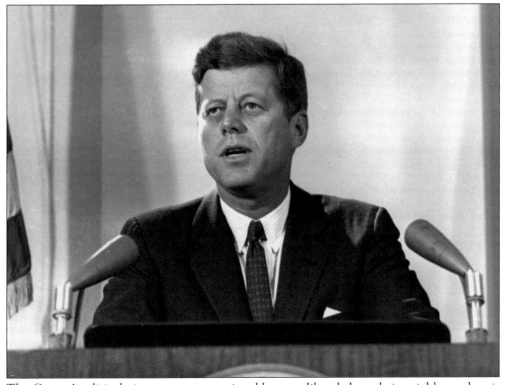

The Carters' political views were unquestionably more liberal than their neighbors when it came to civil rights. They were staunch supporters of Pres. John F. Kennedy (pictured). The slain president would forever serve as a role model for his democratic successor. Jimmy Carter began his political career in earnest, first becoming a member of the Sumter County School Board and then of the Georgia State Senate. (AC.)

The Carter boys, like their parents before them, attended Plains High School. Due to the unpopularity of Pres. Lyndon Johnson's views on civil rights, many in the town of Plains voted for Barry Goldwater in 1964. Not the Carters, though—and the Carter children were sometimes harassed for their beliefs. On one particular occasion, son Chip was beaten up for having an "LBJ '64" sticker on his school binder. (AC.)

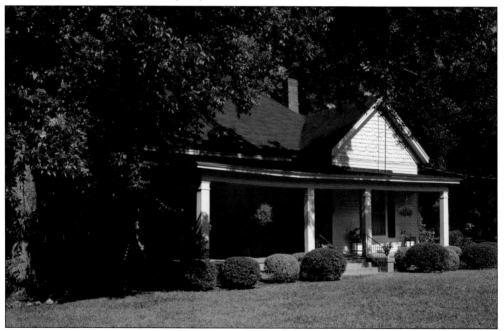

Seen here is Rosalynn Smith Carter's childhood home. She was born here on August 18, 1927. Today, a plaque outside of the home proudly proclaims this fact. When the Carters returned home, Rosalynn's mother, Allie Smith, still resided in the house. She was a federal employee and could not actively support her son-in-law during his early campaigns. (LC.)

The Carters built their ranch-style home in 1961, following two profitable years at the warehouse. It is the only home they have ever owned, and they have made many alterations to it over the years. This includes two frame additions, a guest house, and two garages. The wrought-iron fence that encloses the property once surrounded President Nixon's home in Key Biscayne, Florida. (Charles W. Plant.)

After two terms in the state senate and one failed attempt at the state's top post, Carter would win the governorship of Georgia in 1970, following a four-year campaign effort that began immediately after his 1966 defeat. His success on this second campaign was largely due to his efforts to win over conservative Democrats and portraying himself as a common peanut farmer. (AC.)

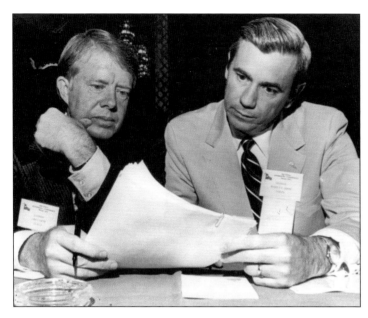

Carter, pictured here with Florida's governor Reubin Askew, made a name for himself as a New South governor. His daring inaugural address proclamation, "I say to you quite frankly that the time for racial discrimination is over," helped catapult him into the national spotlight and onto the cover of *Time* magazine. (AC.)

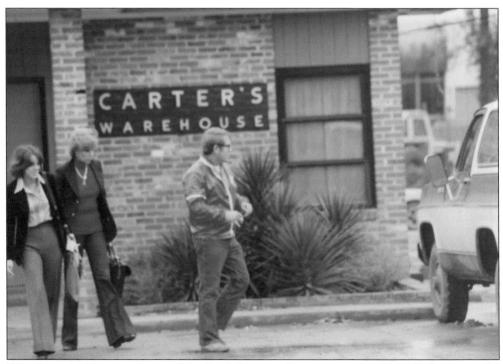

Billy Carter had been in charge of the family business for six years, since Jimmy's election to the governorship. He also purchased the local service station from owner Mill Jennings. It would become a popular gathering place for the national press and local barbecues. It was also the first place local wives came to look for their husbands after work. (Eddie Hunter.)

Several years after the birth of their third son, Jeff, the Carters were blessed with the arrival of little Amy Carter, pictured here with her parents during the 1976 election. Amy was not only the apple of her father's eye; she managed to help project an image of youth and laid-back energy for the candidate. (Charles W. Plant.)

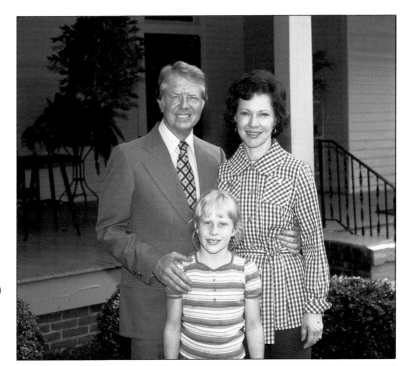

During the first three months of the campaign, the entire Carter family—Rosalynn, their three sons, their wives, and Carter's mother and siblings—traveled to 40 different states, cultivating and nurturing support among the states' press, unions, and party structures. In these early days, it was not uncommon for a potential Carter supporter to be showered by personal phone calls and handwritten letters from both Carters. (Charles W. Plant.)

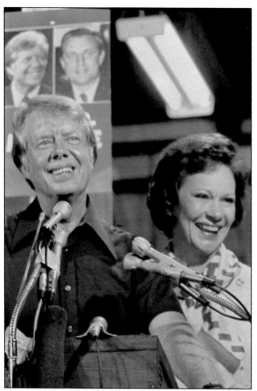

On December 12, 1974, Jimmy Carter officially declared his candidacy for the presidency. The determination of this one man, and the devoted support of his hometown, did not seem to sway many people early on. "Jimmy is running for what?" was a popular headline in the *Atlanta Constitution*, and he is still the only modern president whose announcement was not preserved on film for posterity. This was due to the conviction by many that he would never win. (AC.)

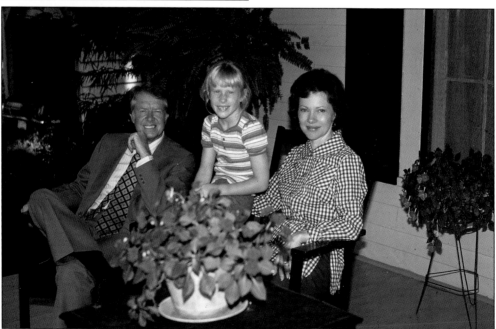

As the Carter presidency began to look like a serious possibility, the town's fathers started to think hard about the community's future. Even in the fall of 1976, there was talk of turning much of the town into a national park. While some of the more ambitious schemes and plots unraveled, the idea of preserving key structures as a park continued to flourish. (Charles W. Plant.)

The start of Carter's campaign was marked by loneliness. No reporters followed him as he made the sometimes embarrassing journey across Iowa and New Hampshire, asking for votes. With a stack of green-and-white brochures in hand, Carter stopped people on the street and said with a smile, "Hello, my name is Jimmy Carter, and I'm going to be your next president." (AC.)

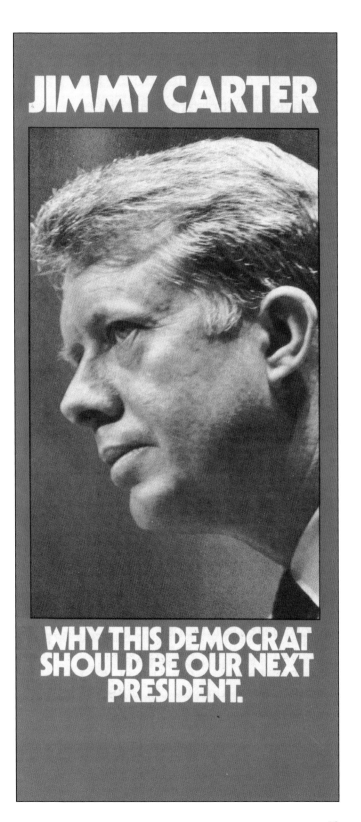

JIMMY CARTER

WHY THIS DEMOCRAT SHOULD BE OUR NEXT PRESIDENT.

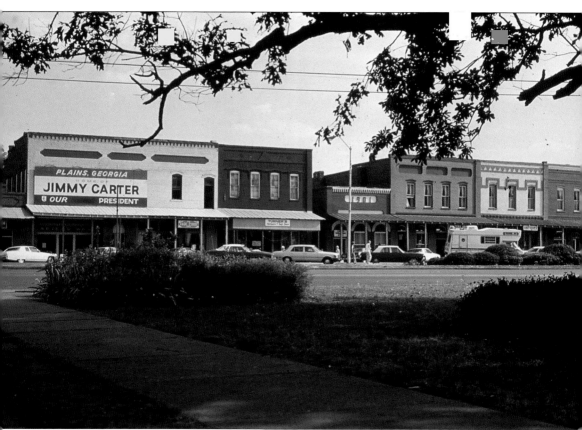

Brother Billy had the now-famous Main Street sign hung originally in 1966. It proclaimed at the time that Plains was the "Home of our next Governor." He changed it in 1970 by painting over the word "next." In 1975, Billy once again hired painters to change the sign so that it read "Home of the Next President." Of course, the morning after the 1976 general election, painters were again called to change the sign. (Charles W. Plant.)

Two

HOME OF
THE NEXT PRESIDENT

One resident remembered it as "waking up to find your home in the middle of a world's fair." Before 1976, it was not uncommon to see local women turning up at the business district in curls or without makeup. After the frequent and prolonged national exposure the town was receiving, they would not dare step foot there without full makeup and hair, because they would quite possibly end up on the evening news. (AC.)

Early on, a key asset of the Carter campaign was Rosalynn Carter. This was particularly true during the primary season, when the future First Lady spent over 70 active days campaigning in Florida. A key state in Carter's road toward the nomination, it was here that Governor Carter would have to face off against the popular and controversial George Wallace. Many Florida delegates claim it was Mrs. Carter who ultimately led them to support the man from Plains. (LC.)

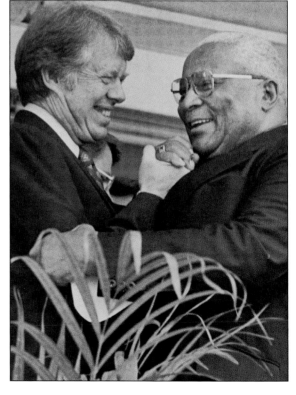

Racial tensions had plagued the Democrats for decades. As a candidate from the Deep South, Jimmy Carter faced the difficult task of bridging the gap between the liberal and conservative wings of the party. Carter, seen here with Martin Luther King Sr., was able to receive universal support among both African Americans and more rural voters, who were supporters of Gov. George Wallace. (LC.)

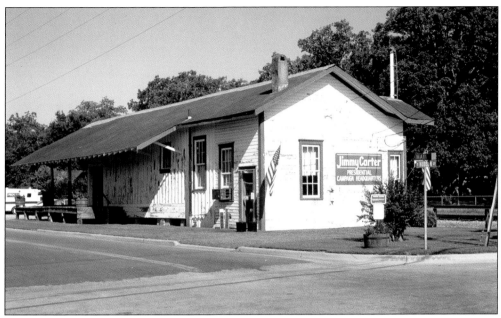

The town's train depot was constructed in 1888 and was, for a time, the only building with a public bathroom. This was the primary reason for its selection as the hometown headquarters for the Carter presidential campaign. The site of numerous hometown primary parties, it was where candidate Carter held interviews when he was in town. As the 1970s dawned, Plains remained largely unchanged. But following Governor Carter's announcement for president, the entire landscape of the community began to change. The primary-night parties would begin at the depot and quickly took on a church potluck atmosphere. It is said that there were rows of flatbed trucks and tiny campers everywhere. (Above, Charles W. Plant; below, Eddie Hunter.)

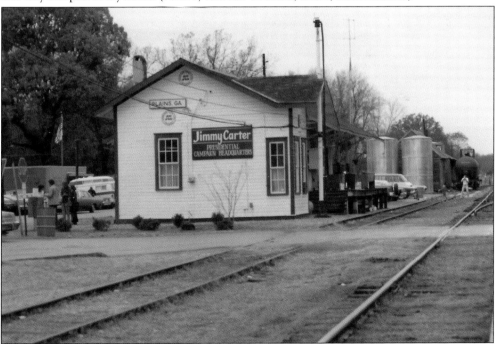

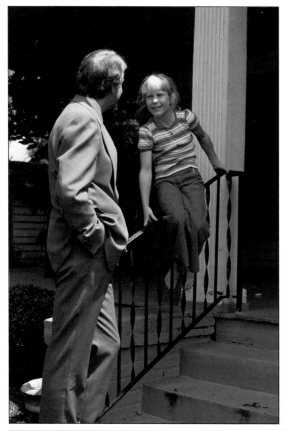

Journalist Richard Hyatt once described Amy Carter as "lemonade and freckles." During the election, Amy, a budding business owner like her father, along with her friend John Gnann, started a lemonade stand. Her best customers were the tourists and members of the press who lined Woodland Drive by the Carter residence. When the road was closed by the Secret Service for security reasons, Amy closed her stand, but not before raising her prices from a nickel to a dime. Some reporters actually used this minor raise in prices in a satirical article. When one reporter jokingly complained to the candidate about the new prices, Jimmy Carter did not miss a beat, joking that members of the press should pay a quarter, because they had expense accounts. (Both, Charles W. Plant.)

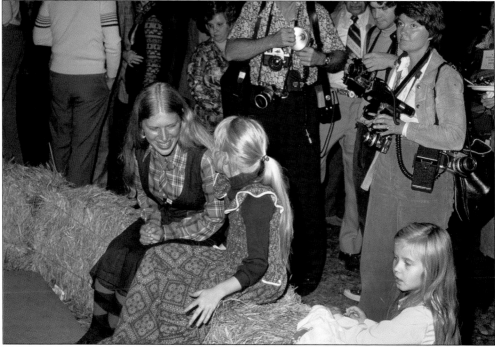

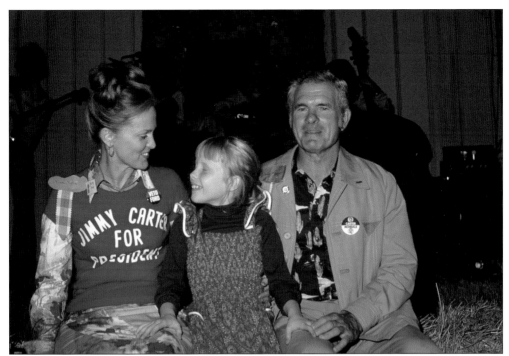

Betty (left) and John Pope (right) pose with Amy Carter during a fundraiser for the newly minted Democratic frontrunner. The Popes were early members of the Peanut Brigade, a group of volunteers that traveled to New Hampshire and Iowa on their own money to campaign for their favorite son. Betty is a cousin of President Carter, and the two couples frequently socialized prior to his involvement in politics. (Charles W. Plant.)

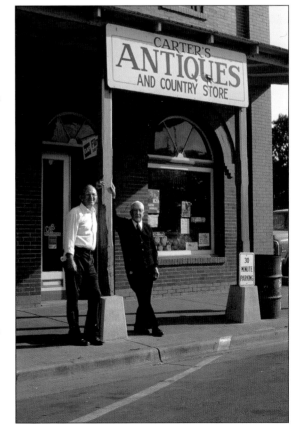

Jimmy Carter's uncle, Alton Carter (left), and first cousin, state senator Hugh Carter (right), stand outside of their antique store. By the summer of 1976, there was a vast number of small companies operating in the Main Street area. At one point, six vans, two small trams, and even a mull wagon transported visitors across Plains on guided tours. Overnight, there were signs everywhere, such as "Peanut Special Mini Trains" and "Carter Country Tours." (Charles W. Plant.)

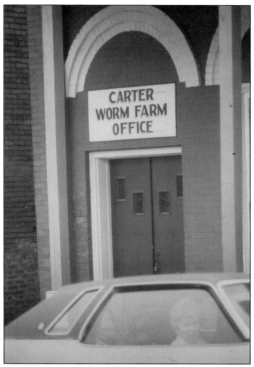

State senator Hugh Carter was a worm farmer as well as an antiques dealer. He held his cousin's former senate seat for over 14 years and was highly active in the 1976 presidential campaign. For years, tourists crowded his store, tickled that he was a relative of the president. Hugh eagerly reminisced about his life in Plains. (Eddie Hunter.)

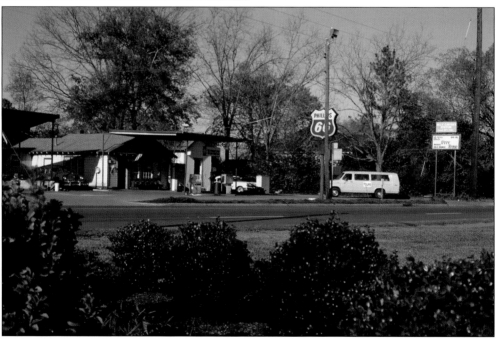

Little shops began to open up in the summer of 1976 to accommodate the stream of tourists and reporters that flocked into town. Some even went so far as to salvage old beer cans from Billy Carter's service station, and these were quickly purchased by visitors. With 10,000 visitors flooding into the town each day, many locals started doing most of their shopping in nearby Americus. (Charles W. Plant.)

One morning in 1976, Billy Carter was driving his pickup truck through Plains when he spotted Jimmy walking with Sen. John Glenn of Ohio, a possible vice-presidential choice in town for an interview with the Democratic nominee. As the nominee introduced the senator to Billy Carter, the younger brother reached into his truck, chose a can of beer, and popped the cap. Jimmy Carter seemed to shudder. (Eddie Hunter.)

Jimmy Carter called his mother "the most influential woman in my life." She would simply describe him as "just an ordinary little boy." Lillian Carter was a nurse, a Peace Corps volunteer at the age of 68, a lifelong supporter of civil rights, and a gifted storyteller. When her son announced that he was running for president, she famously asked, "Of what?" (Eddie Hunter.)

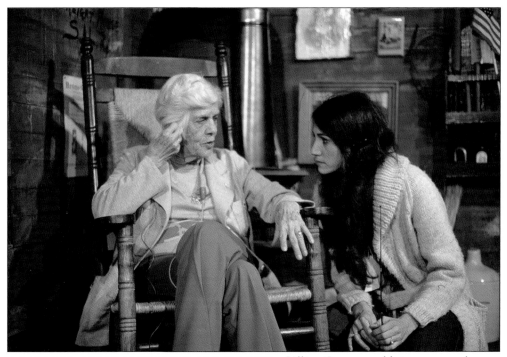

Lillian Carter would sign autographs at the depot all day long, "but if a person reached out to hug her or shake her hand," recalled Eddie Hunter, "she would pitch a fit." After a while, Miss Lillian developed a love/hate relationship with campaigning. She was originally going to merely watch Amy Carter while her parents traveled, but Lillian began to yearn for the thrills and excitement that came with daily campaigning. (Above, Charles W. Plant; left, Eddie Hunter.)

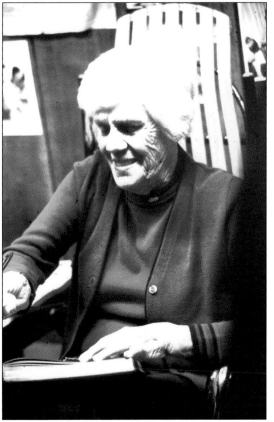

Following Watergate, honesty was one of the key qualities many Americans claimed they were looking for in a presidential candidate. This led Jimmy Carter to declare that he would "never tell a lie or make a misleading statement." When reporters questioned Miss Lillian about the candidate's pledge, she would often make humor out of it. "Jimmy says he'll never tell a lie. Well, I lie all the time. I have to—to balance the family ticket." (Above, Charles W. Plant; right, Eddie Hunter.)

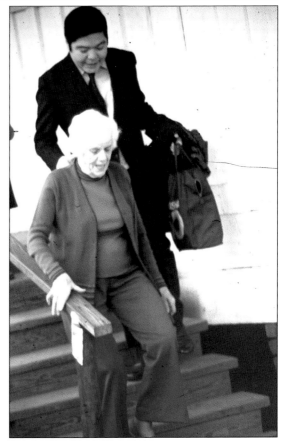

"Should we believe your son when he tells us he won't lie to us?" one reporter asked during an in-depth interview with Miss Lillian. "Well," she said to the reporter, "Jimmy tells white lies." When the reporter asked Miss Lillian to explain what that meant, she replied with relish, "Remember how when I met you at the door I told you I was glad to see you?" (Eddie Hunter.)

At the age of 68, Miss Lillian went to India as a Peace Corps volunteer. A registered nurse, she spent the next two years working in a clinic outside of Bombay. She worked on the presidential campaign full time and became a notable guest on the talk-show circuit. Upon Miss Lillian's return home, the Carter children built her this pond house. (Charles W. Plant.)

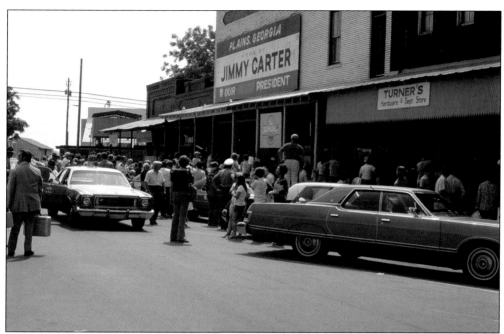

Following Carter's victories in Iowa and New Hampshire, the sleepy town of Plains became packed with tourists. Within just one year, this small community of 600 would be visited by thousands of strangers daily. Some came simply out of curiosity. Others came with ambitious efforts to make quick money. Most came with the knowledge that they were witnessing history in the making. (Charles W. Plant.)

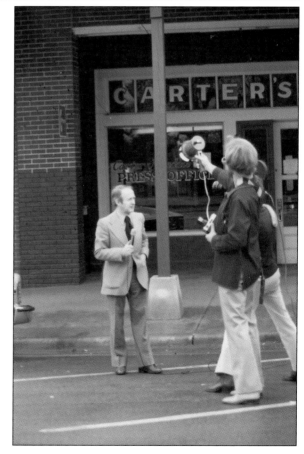

"It all changed so dramatically and so fast," said former White House appointments secretary Phil Wise. "They had to put in pay phones so that the reporters could file their stories in time." Before long, a constant series of social events was taking place in town. Primary nights, which occurred on Tuesdays, became the biggest night of the week in Plains. (Eddie Hunter.)

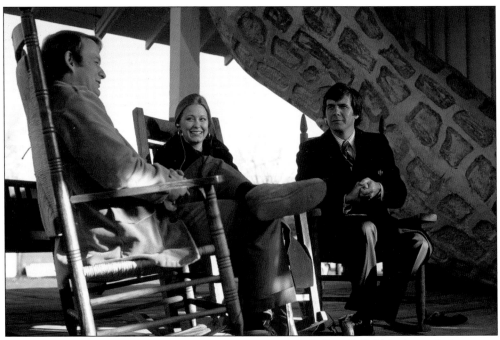

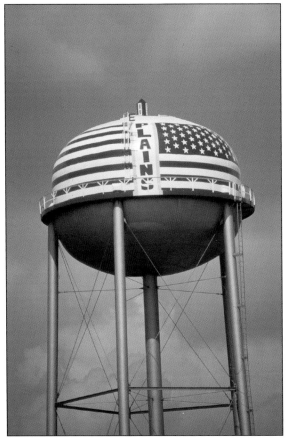

Jody Powell (left) is shown being interviewed by Jane Pauley (center) and Tom Brokaw (right) of *NBC Nightly News* at the train depot. During the 1976 campaign, Powell was noted for his energy and great relationships with the press. He frequently called reporters from pay telephones while on the road. He and campaign manager Ham Jordan made Plains a major focus of the campaign, knowing it had an emotional resonance with the public. (Charles W. Plant.)

The new water tower was erected in the summer of 1976. A group out of Albany was contracted to dismantle the old water tower, piece by piece. The town had not used the rusty tower for years. But, according to Billy Carter, its dismantling was necessary, "There were people climbing up it. One fellow got up to the top and wouldn't come down." (Charles W. Plant.)

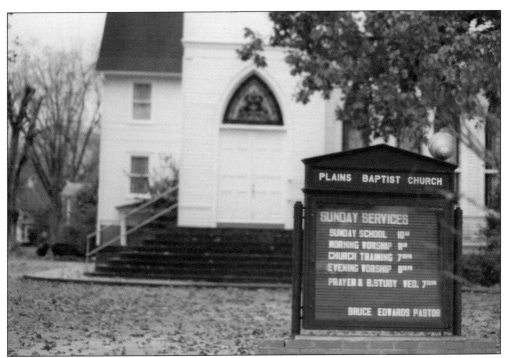

Not long after the election, for-sale signs went up across the entire town of Plains. Many Carter neighbors made a pretty penny selling their houses to wealthy fans eager to call the new First Family next-door neighbors. The Carter family was often away campaigning across the country during the week. Friday night, they would return home to Plains and spend the weekend together, going over notes. Each Sunday, they would attend services at Plains Baptist Church (pictured). The church became the site of protests and activism by individuals trying to drum up attention for their causes. (Both, Eddie Hunter.)

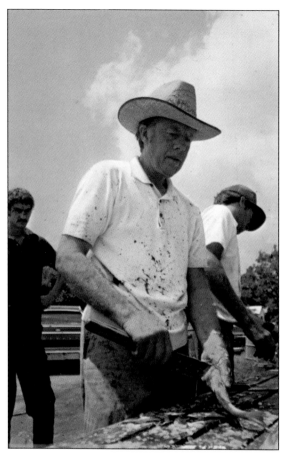

With the primary season over, the Democratic nominee returned home to Plains to rest before the customary start of the fall campaign around Labor Day. The press followed him wherever he went—to fish fries, the family pond house, and the train depot. This was also when the first tourist shuttles and vans began to operate in the town. Before long, there seemed to be more and bigger news circulating throughout the town. Billy Carter eventually hired an agent, and T-shirts reading "Billy Who 1984" were being sold in town. (Both, AC.)

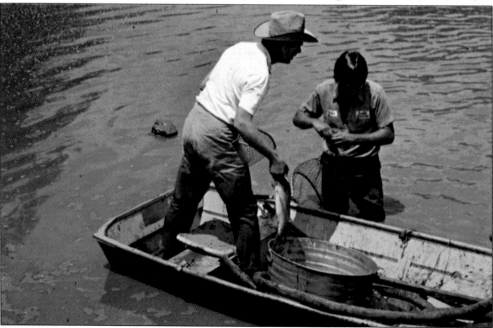

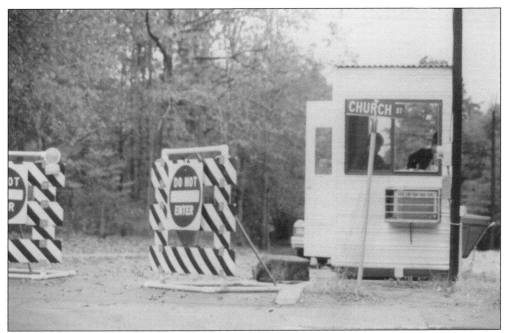

A guard gate was set up at the entrance of the street where America's new First Family resided. Today, a similar, more permanent structure is in its place. The closure of the entire street was a bit off-putting to some locals, while others seemed to enjoy the added security. (Eddie Hunter.)

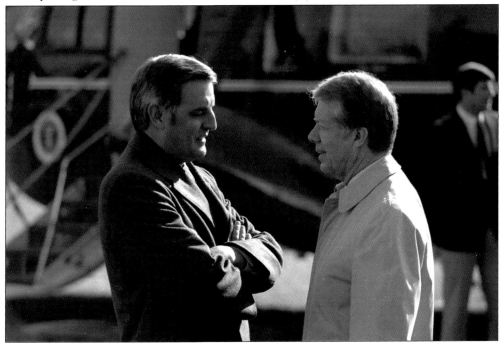

Before making his choice for vice president, Democratic nominee Jimmy Carter interviewed those on his shortlist in Plains. The list included John Glenn and Walter Mondale. After a few weeks of intense interviews, Minnesota senator Mondale was selected to join the ticket. The two men quickly formed both a lasting friendship and a productive working relationship. (LC.)

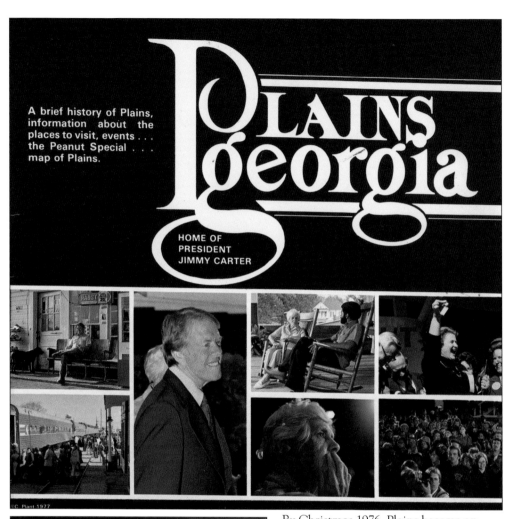

A brief history of Plains, information about the places to visit, events . . . the Peanut Special . . . map of Plains.

PLAINS georgia

HOME OF PRESIDENT JIMMY CARTER

©C. Plant 1977

For additional copies contact:
Depot Gift Shop
Main Street
Plains, Georgia 31780

Design and Photographs by Charles Plant

By Christmas 1976, Plains became an industry unto itself. President-elect Carter's uncle Alton took full advantage of this uptake in tourism, creating his own line of postcards and Carter-themed merchandise. At the same time, Plains hired its first deputy police officer, and the Secret Service installed guard booths and security devices along Woodland Drive to secure the Carters' home. Appealing to the steady wave of tourists that came into the town daily looking for trinkets, store owners quickly converted their shops from mercantile to merchandising. (Both, Charles W. Plant.)

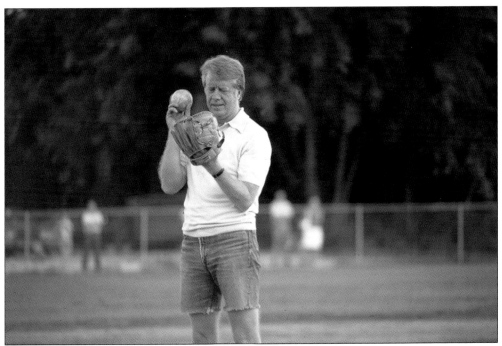

Here, Jimmy (above) and Billy Carter (below) play softball on the Plains High School field with the Atlanta Braves. The Carter brothers frequently played competitive games with each other, President Carter serving as captain of the Secret Service team and Billy serving as captain of the press corps team. In 1976, the Atlanta Braves were having a terrible season, and the crowds that filled Plains on this day were larger than most of the team's crowds that year. (Both, Charles W. Plant.)

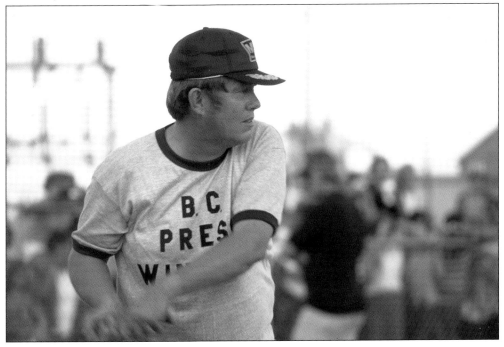

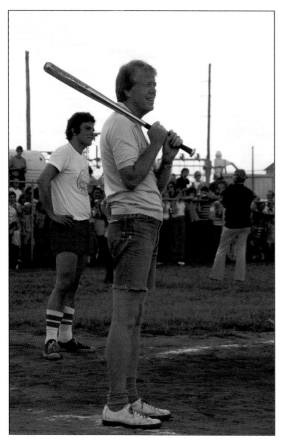

Social and sporting events were magical for many Americans to witness. In the previous 20 years, the postwar American way of living had transformed the presidency, turning the officeholder into something more akin to an emperor or a king. A possible future president of the United States in jeans and a T-shirt playing baseball signaled a return to a more modest presidency. (Charles W. Plant.)

Carter had a double-digit lead going into the fall, and he spent the entire summer in Plains, relaxing. It was during this time that he made a serious error. Carter consented to an interview with *Playboy* magazine, and he discussed a number of personal issues. For many voters, Carter's admission to having "lusted" in his heart was disconcerting, and Carter's lead slipped to nothing. (Charles W. Plant.)

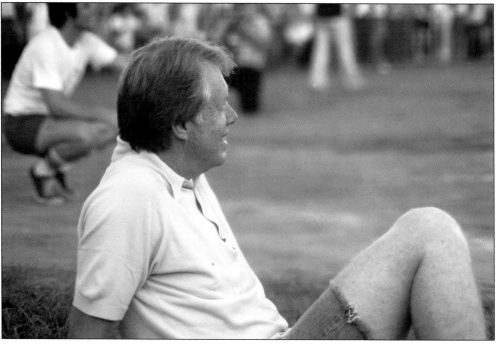

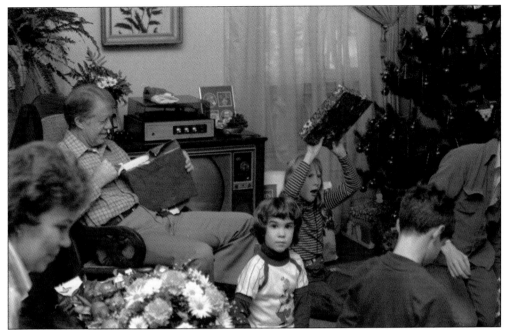

President Carter and his family open up presents on Christmas day in their Plains home. The president made it a point to spend as much time as possible in his hometown. This was particularly true during the holidays—the First Family spent a majority of them in Plains. However, this would prove a logistical problem as time went on. (LC.)

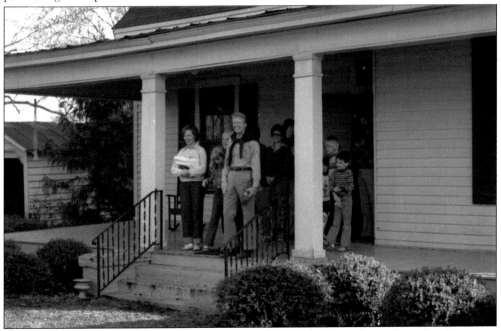

The First Family leaves the home of Allie Smith, the president's mother-in-law, after Christmas lunch. The Carters, shocked at how congested the town had become, started spending more of their time away from the White House at Camp David. There, in the private presidential retreat, the family could relax with minimal interference from the Secret Service. (LC.)

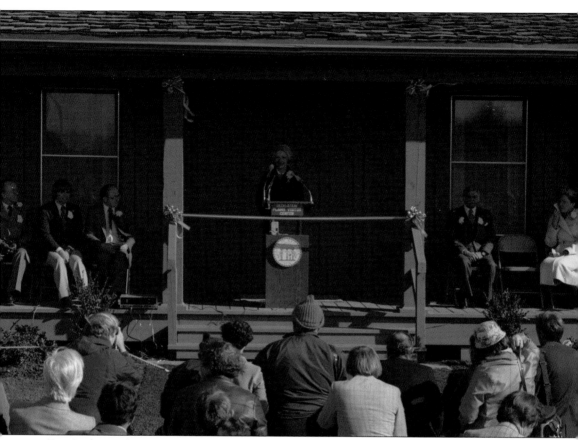

First Lady Rosalynn Carter serves as master of ceremonies at the unveiling of the Georgia State Visitors Center in Plains. The center was opened following the huge burst of activity that turned the town into a surprising tourist destination. Not long after, one farm in the community sold for over $2,000 an acre. The new owner, hoping to build on the Carter mania, planned on opening an amusement park. (LC.)

Three

A Bicentennial Election

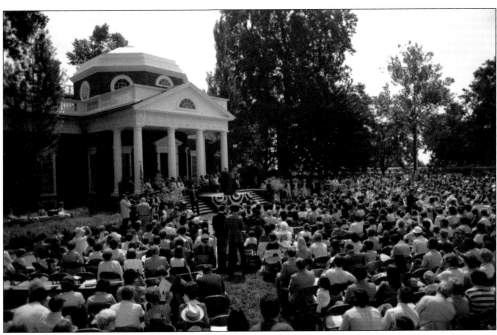

Pres. Gerald Ford speaks at Independence Hall in Philadelphia, Pennsylvania. The ceremonial event marked the nation's bicentennial. Because the states could not agree on a national theme, the president had to travel to dozens of states to celebrate this important moment in the nation's history. The Ford campaign was excited, because this meant great exposure for the candidate. (GRF.)

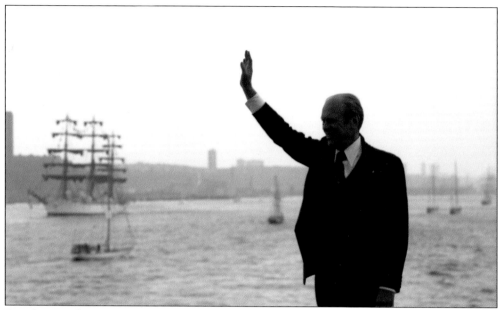

President Ford initiates the ringing of bicentennial bells across the nation while on the flight deck of the USS *Forrestal*. He and Bicentennial Administration head John Warner observed Operation Sail activities in New York Harbor on July 4, 1976. This entire day was a monumental event for both the nation and the Ford presidency. (GRF.)

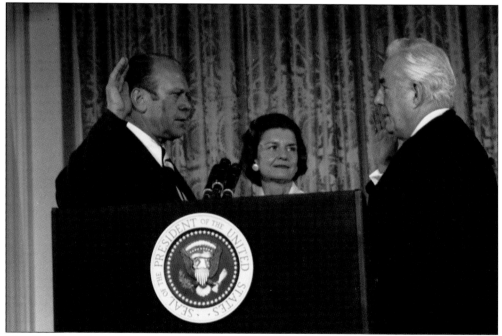

Vice President Ford is sworn in as the nation's 38th president in the East Room of the White House. Ford, a former congressman, was the first "unelected" president in the United States, having been appointed to the vice presidency by Richard Nixon. Ford achieved the unprecedented feat of holding the nation's two highest offices without running on a national ticket thanks to the Twenty-Fifth Amendment. (GRF.)

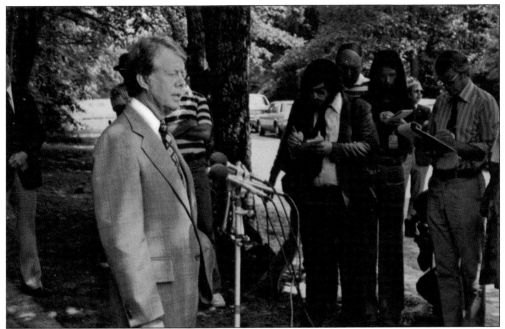

Jimmy Carter would often hold press conferences on his front lawn and at the depot. While the Carter compound was closed to the general public and served as an ideal setting for brief press sessions, it was also very critical for candidate Carter to appear at the depot. These appearances would always draw large crowds. (AC.)

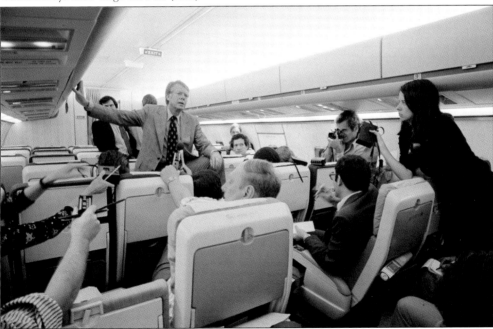

When Carter won the Democratic nomination, a collective wave of excitement came through the town. "What if he wins?!" was the question on everyone's mind. As one native remembers, the exchanges usually ended with, "No one is supposed to know a president! We'll just have to call him Jimmy like always." (LC.)

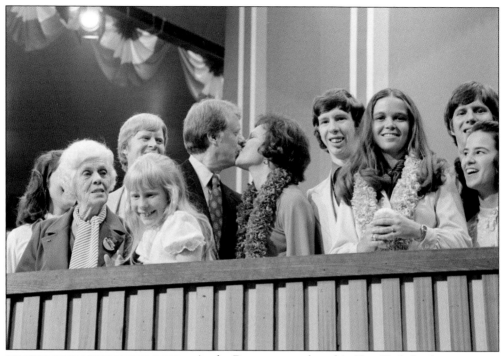

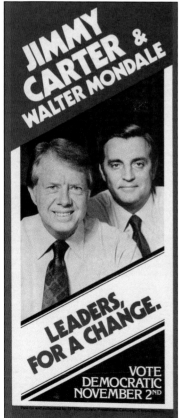

As the Democrats gathered in New York for their national convention, they arrived knowing that Carter had a lock on the nomination. With over 2,000 delegates, he won on the first ballot. While in New York, a reporter asked Amy Carter what she thought of the event. "Not much," she said. (LC.)

The Carter/Mondale team is seen here on a campaign brochure. Carter said, "We stand at a turning point. At a dawn of our nation's third century, this year's election could very well be the most important in our history." (AC.)

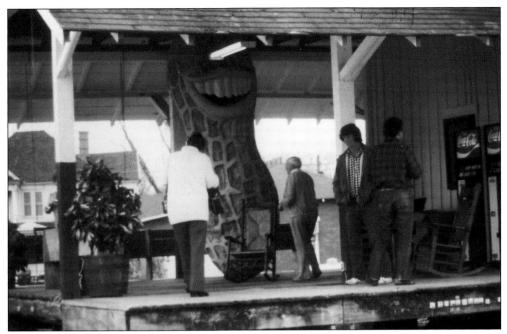

The Smiling Peanut was brought to Plains from a Carter rally in Indiana. It was first placed here, at the depot campaign headquarters. But Maxine Reese, the local campaign coordinator, decided to place a store in the depot, and the peanut was moved to its current location on Bond Street. It remains a popular destination for tourists. (Eddie Hunter.)

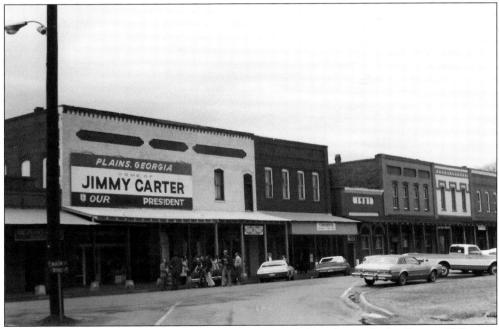

There is no way to describe the relationship the town of Plains has with the Carters. Following Jimmy Carter's nomination, the entire town began to buzz with excitement. To earn extra money for the candidate, they actually sold cotton and cattle in the months leading up to the fall national election. (Eddie Hunter.)

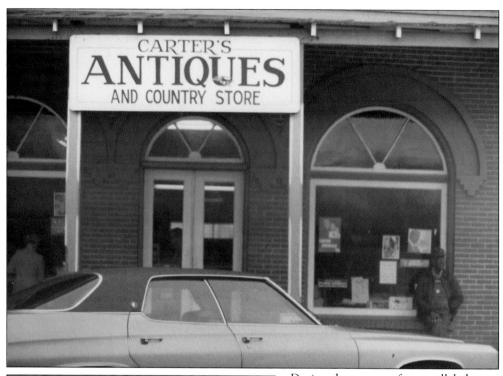

During these years of unparalleled tourism, Hugh Carter turned the family's old general store into, as the *New York Times* once described it, "a tourist mecca," particularly during the Carter presidency. Visiting reporters would often make it their first stop in town, and Hugh Carter's family lore became so beloved that he wrote his own book, the first published account of life inside the Carter family. Although Miss Lillian thought it was a personal betrayal, the book was very successful. Once Jimmy Carter became a viable contender for the Democratic nomination, he was given Secret Service protection. The agents wanted to blend in, so they purchased overalls in Hugh's store. (Both, Eddie Hunter.)

This image, designed by photographer Charles Plant, was sold in the depot gift shop. The Carters would often sign the drawings as a way to raise money for the campaign. This, like so many others, was the idea of Maxine Reese, who ran the campaign in Sumter County. She was a marvel of a woman and a political powerhouse. (Charles W. Plant.)

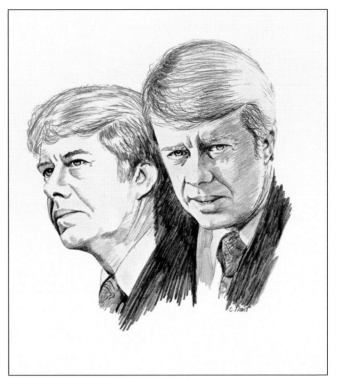

According to author Richard Hyatt, "Miss Lillian held court at the depot like the Queen mother." There was always a constant stream of people wanting to touch her and reach out to her. She finally put up a sign that said, "Don't touch Miss Lillian! Just talk and keep moving." (Charles W. Plant.)

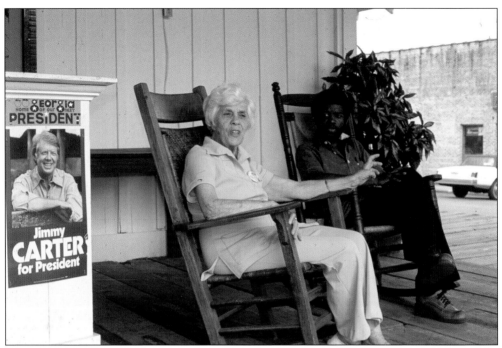

Miss Lillian is shown here being interviewed at the depot. One crafty idea to help promote the city was to sell one square inch of land near the depot to interested buyers, complete with a signed certificate. Anyone could purchase a piece of Plains for $5. (Charles W. Plant.)

Miss Lillian strongly disliked the commercialization of the town, and she soon gave up her daily journeys to the depot. Billy Carter actually moved from Plains to a town 19 miles away. (Charles W. Plant.)

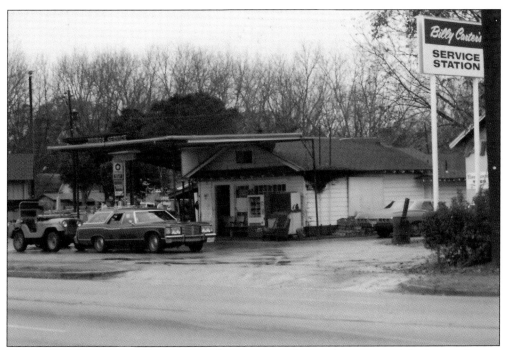

The increased interest in Plains meant that it attracted to its doors some of the best and worst kinds of people. Often, Billy Carter's service station was filled with strangers looking to rub elbows with him or, in some cases, promote strange causes. (Eddie Hunter.)

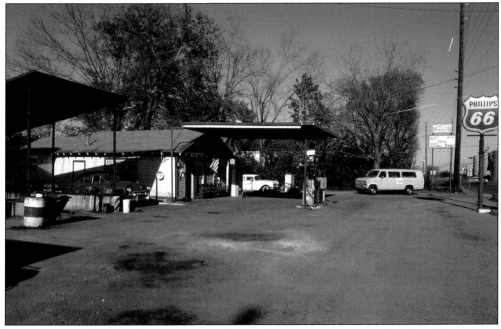

In the summer of 1976, as the press gathered around Plains to get acquainted with the Democratic nominee and his family, Billy Carter quickly became a national celebrity. "I got a red neck, white socks, and Blue Ribbon beer," Billy would say with a grin. His service station was always packed with an odd mix of regulars and journalism royalty. (Charles W. Plant.)

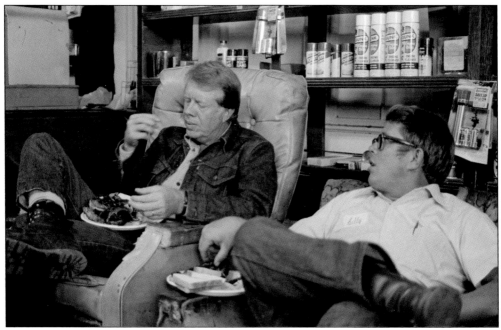

Here, Jimmy Carter eats with his brother Billy during a campaign stop at Billy's gas station in their hometown of Plains, Georgia. The Carter brothers for years suffered from a strained relationship. Billy later admitted he was "mad as hell" when Jimmy, who had been away in the Navy since Billy was six, returned to take over the family business. (LC.)

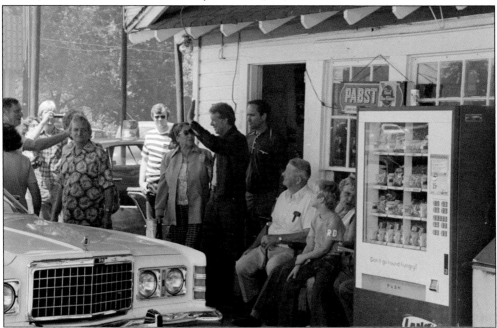

When asked about his family, Billy, without missing a beat, let off one of the best quips of the entire election cycle: "My mother went into the Peace Corps when she was sixty-eight. My one sister is a motorcycle freak, my other sister is a Holy Roller evangelist, and my brother is running for president. I'm the only sane one in the family." (LC.)

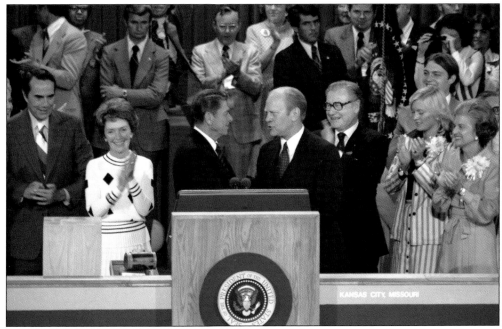

Pres. Gerald Ford (right) received a slim majority of delegates at the Republican National Convention, finally managing to defeat the serious challenge of Ronald Reagan (left) and win his party's nomination. The two had battled each other for months. As a result, the party was bitterly divided. Many conservative Republicans thought Ford was too tainted by his connection to Richard Nixon to defeat Carter in November. (GRF.)

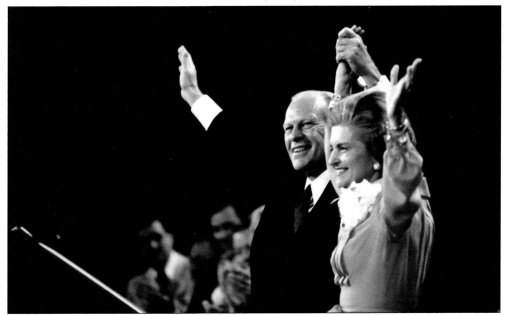

President Ford and First Lady Betty Ford accept the Republican Party's nomination. After defeating Ronald Reagan at the 11th hour, the road to retaining the White House looked very bleak for the president. Ford had given Richard Nixon a full pardon shortly after assuming office. Many people believed that the pardon was the result of a secret deal between the two men. (GRF.)

AMERICA
1776
★ ★ ★
1976

Bicentennial

Faneuil Hall
"Cradle of Liberty"
Boston.

❈ *Old North Church*
Boston Mass.

"Old
Ironsides"

This postcard was one of thousands of items produced during the nation's bicentennial. The longing for national renewal and patriotic pride was a theme that the Carter campaign capitalized on with great effect. (AC.)

In 1976 and 1980, the Democrats picked as their campaign colors green and white. This was due largely to Carter's support of environmental issues. (AC.)

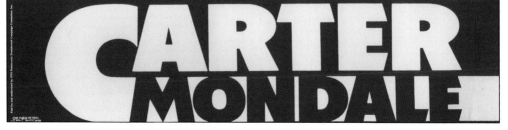

This campaign button and many others were used to spin the Carter candidacy as laid back and humorous. It was the first time the presidency was connected with cartoon images like Carter's grin or the candidate as a peanut. (AC.)

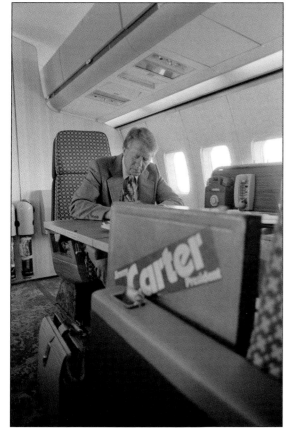

Jimmy Carter had spent two years of his life campaigning for the presidency. He had traveled over 50,000 miles, visited 37 states, and delivered 200 speeches before any other candidate even announced. Now aboard his official campaign plane, Peanut One, he was coming to the end of his marathon run for the highest office in the land. (LC.)

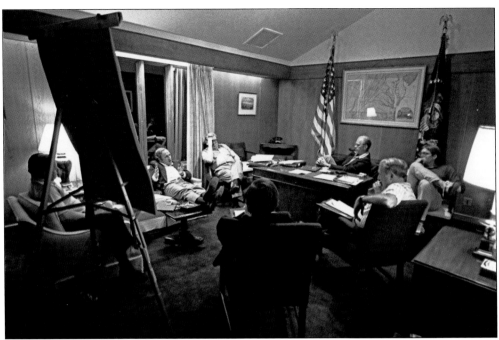

White House chief of staff Dick Cheney comments during a campaign strategy session. Shown here are, clockwise from upper right, President Ford, his son Jack Ford, counselor John Marsh, Robert M. Teeter of Market Opinion Research Corp., Ford's committee deputy chairman for political organization Stuart Spencer, Cheney, and counselor and speechwriter Robert Hartmann. (GRF.)

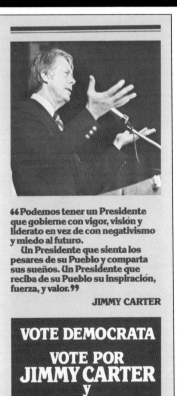

66 Podemos tener un Presidente que gobierne con vigor, visión y liderato en vez de con negativismo y miedo al futuro.
Un Presidente que sienta los pesares de su Pueblo y comparta sus sueños. Un Presidente que reciba de su Pueblo su inspiración, fuerza, y valor. 99

JIMMY CARTER

VOTE DEMOCRATA
VOTE POR
JIMMY CARTER
y
WALTER MONDALE

Pagado y autorizado por El Comité De Campaña Presidencial Demócrata 1976 Incorporado.

The Carter campaign was the first to print Spanish-language advertisements, in a concentrated effort to attract support among Latino voters. This, along with Carter's overwhelming support from minorities across the country, was seen as a primary reason for his victory in the fall. (AC.)

PULL 1st BIG LEVER

Elect JIMMY CARTER

VOTE DEMOCRATIC

By the fall, the Ford campaign was desperate to stop the Carter momentum. The Democratic challenger was crisscrossing the nation and had maintained a decisive lead. The Ford campaign's solution was a series of televised debates. (GRF.)

The Debates

JIMMY CARTER GERALD FORD

TAKE YOUR PICK IN "76"

This postcard marks the symbolic connection between the Carter/Ford debates and the Kennedy/Nixon debates. The 1976 presidential debates were the first of their kind since the fabled showdowns in 1960. (AC.)

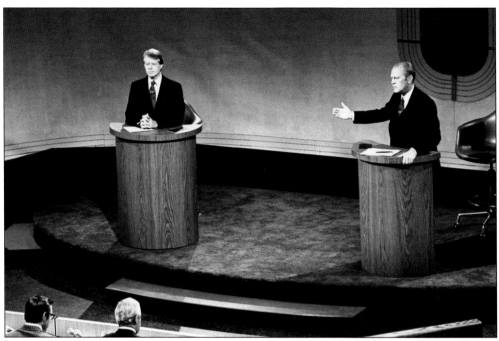

Jimmy Carter and Pres. Gerald Ford appear in the second debate, at San Francisco's Palace of Fine Arts. It was here that Ford made a memorable flub on Poland that stopped his momentum in the final month of the election. (AC.)

"I see an America," said Carter, "that has turned away from scandal and corruption. . . . A president who is not isolated from our people, but a president who feels your pain and shares your dreams." (AC.)

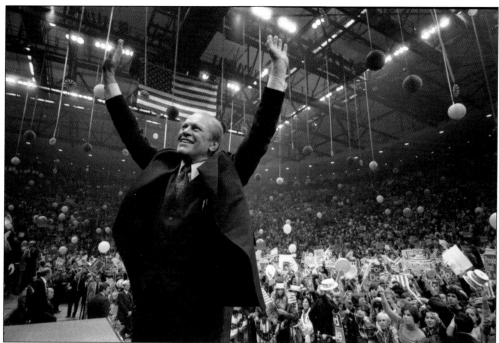

The election grew increasingly close. Ford's strategy was to try to win five of eight elector-rich states: California, Illinois, Michigan, New Jersey, New York, Ohio, Pennsylvania, and Texas. He won four, but not five. Carter won with an interesting coalition of the entire Old South (except Virginia) and Northern industrial powers such as New York and Pennsylvania. (GRF.)

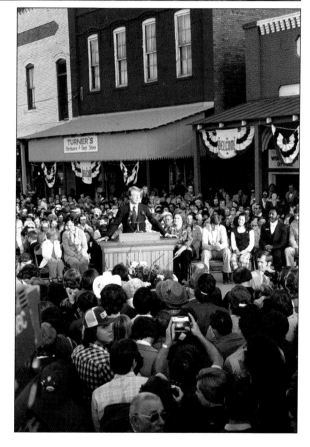

Some felt that the tiny town of Plains took on the aura of an old Hollywood set on election night. By midday, crowds were pouring into the town. Candidate Carter appeared at around 5:00 p.m., speaking on a makeshift platform and addressing the thousands now gathered around it. After the Carters left for Atlanta to await their electoral fate, the crowds only grew larger. (Charles W. Plant.)

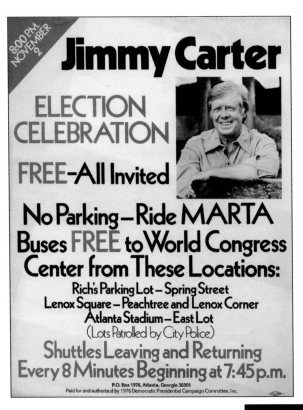

Jimmy Carter

8:00 P.M.
NOVEMBER 2

ELECTION CELEBRATION

FREE-All Invited

No Parking – Ride MARTA Buses FREE to World Congress Center from These Locations:

Rich's Parking Lot – Spring Street
Lenox Square – Peachtree and Lenox Corner
Atlanta Stadium – East Lot
(Lots Patrolled by City Police)

Shuttles Leaving and Returning
Every 8 Minutes Beginning at 7:45 p.m.

P.O. Box 1976, Atlanta, Georgia 30301
Paid for and authorized by 1976 Democratic Presidential Campaign Committee, Inc.

Just two days before the election, an African American minister was denied entry to the Plains Baptist Church. The Ford campaign used this incident to claim that Carter was a moral hypocrite. Yet, by Election Day, Carter's prospects for victory seemed bright. The candidate and his inner circle gathered at the World Congress Center in Atlanta for what they knew was going to be a long night. (LC.)

When it became official that Carter was going to win, Miss Lillian, Maxine Reese, and a handful of other women opened up their coats and reveled white-and-green jerseys, each carrying the words "Jimmy Won 76!" Those wearing the jerseys vowed not to take off their coats if Carter lost that night. (Charles W. Plant.)

A frustrated President Ford watches as his early election-night lead begins to slip away. Democratic nominee Jimmy Carter began the fall campaign with an impressive 20-point lead, which he quickly lost following a series of campaign missteps. Ford's inner circle was hopeful, until New York was called early for Carter. (GRF.)

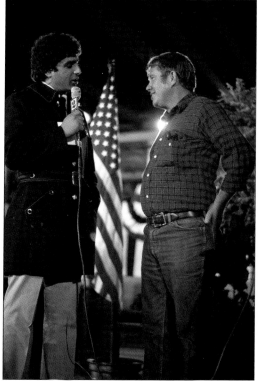

During the chilly evening on election night, three local high school bands performed, barbecue chicken was served, and oil drums housed roaring fires. Television cameras and photographers were a constant presence that night. Billy Carter, with a beer and cigarette in hand, informed a reporter on live television that the town was "going to hell." (Charles W. Plant.)

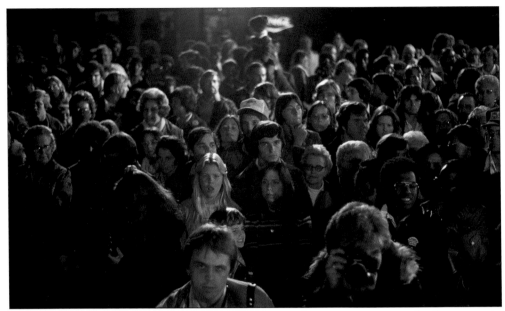

Election night in Plains was, according to many, a time for waiting—waiting for Carter to win and then for Carter to return home. As the results started to come in, thousands packed the small business district of Plains. Godwin's Pharmacy, located across from the train depot, was packed with customers for nearly two days. (Charles W. Plant.)

The final vote for the 1976 presidential election night was 50.1 percent for Jimmy Carter and 48 percent for Gerald Ford. It took some time for the voters in Mississippi to put Carter over the top, which did not take place until 3:00 a.m. Carter would receive over 90 percent of the African American vote and most of the rural vote. (Charles W. Plant.)

Plains was packed with supporters, and the bright pink sunlight of the early morning cropped up over the buildings of Main Street, bathing those on the depot platform with warm sunshine. Jimmy Carter returned home to say thank you. (Charles W. Plant.)

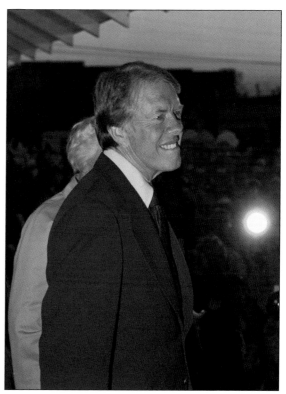

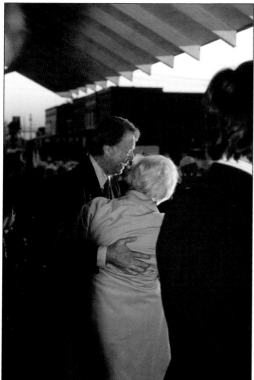

After climbing up the crowded depot, Carter embraced his mother, brother, and sisters. He was given a copy of the *Columbus Enquirer* from cousin Betty Pope. Its headline read "Carter Wins." The new president-elect held it up triumphantly to the crowd. (Charles W. Plant.)

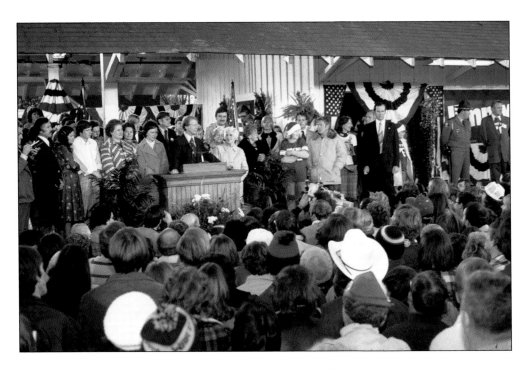

Jimmy Carter spoke to the crowd: "In 22 months, I haven't been choked up. . . . But when we drove into town, and saw so many people foolish enough to be out in Plains. All the others running for president didn't have people helping them who would stay up all night in Plains." (Both, Charles W. Plant.)

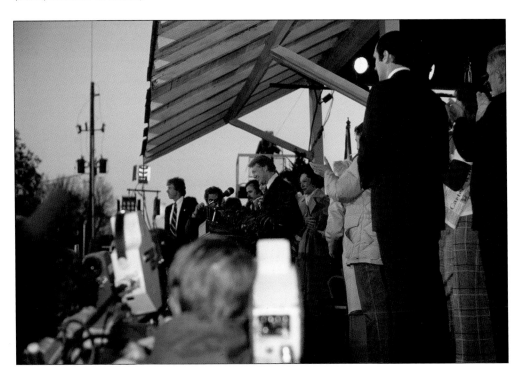

Four

PLAINS GOES TO DC

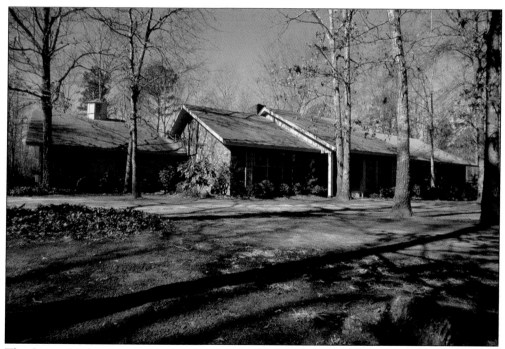

The Carter residence was an active location for cabinet interviews during the transition period. Many busloads of potential candidates and aids were driven into the oak-shaded compound. "He was an outsider," said aide Phil Wise; "that was a huge part of his appeal." But now it was slowly becoming apparent that Washington was slowly making its way to Plains. (Charles W. Plant.)

1977 Inaugural Guide to Washington

A new spirit, a new commitment, a new America.

The official 1977 inaugural program read that the nation was celebrating "a new spirit, a new commitment, a new America." Printed on recycled parchment paper and sporting various painted murals, it was a celebration for a new populist awakening in America. "When you're in Washington for the Inauguration, look around. You're going to see a new openness," said President-elect Carter on the booklet's front page. "You're going to sense a new and vital spirit . . . a spirit which is going to grow and spread." (AC.)

This is the official parade map of the 1977 inauguration. The day included many official events opened to the public. The Carter inauguration was meant to be a populist awakening in America, a way to heal the divisive nature in Washington by bringing in an outsider divorced from the usual give-and-take of politics. (AC.)

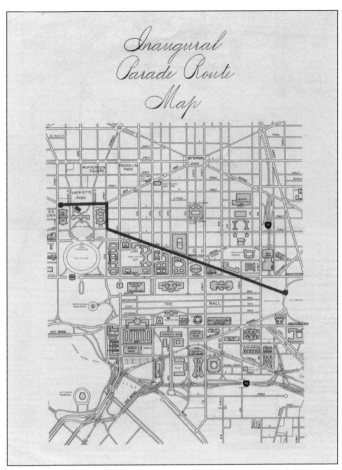

As with the campaign, the inauguration was accompanied by a wave of merchandise for party faithful to consume. Everything from gold medals to paperweights was made and quickly being sold across the nation. (AC.)

Walter Mondale was the first vice presidential candidate in modern times to arguably share the spotlight with the top of the ticket. Many contemporaries praised his inclusion on the ticket, and he is often viewed as one of the nation's finest vice presidents. (AC.)

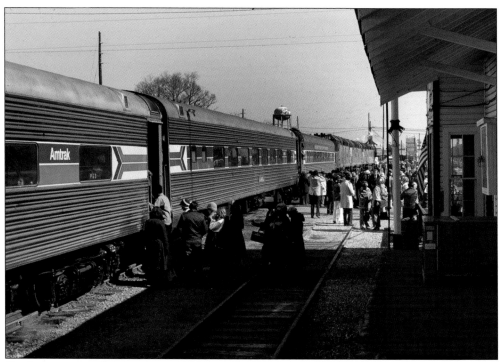

On the morning of January 19, 1977, a special train of 18 cars filled to capacity left Plains, headed for the nation's capital. It was reserved by Maxine Reese long before President-elect Carter had even won the Democratic Party's nomination. The journey is still vividly described by many Peanut Brigade veterans as a wonderful and unbelievable all-day party. (Charles W. Plant.)

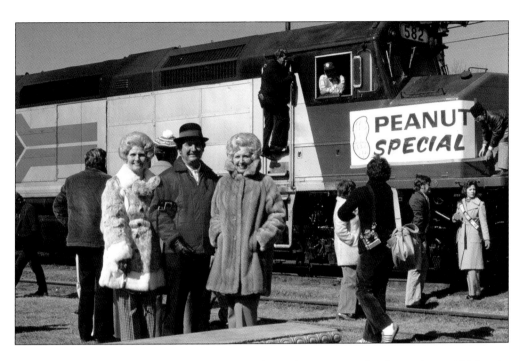

The old train depot once again served railroad travelers, now in the form of over 300 locals. President-elect Carter, also on his way to the nation's capital, stopped briefly at the depot to wish everyone a pleasant trip before driving off to board Air Force One. Carter was in such a hurry to make the waiting plane that he left town without his mother. When the error was discovered, the entire motorcade turned around and picked up a furious Miss Lillian. (Both, Charles W. Plant.)

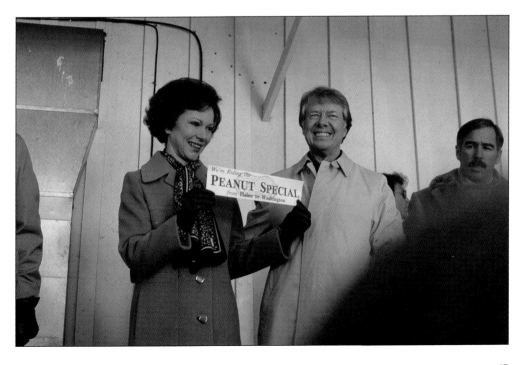

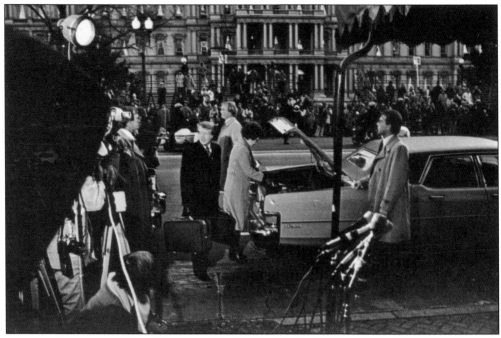

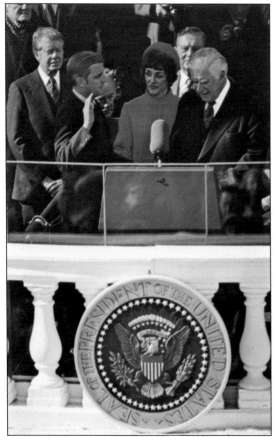

President-elect and Rosalynn Carter are seen the day before the inauguration, carrying their own bags into Blair House. They had earlier made headlines by carrying their own bags off of Air Force One. (AC.)

The oath of office was administered to Vice Pres. Walter Mondale by Speaker of the House Thomas "Tip" O'Neill. This was the first attempt by the new administration to form a lasting partnership with the Congress. (AC.)

Chief Justice Warren E. Burger administered the oath of office to Jimmy Carter, who took the oath with a family Bible, open to Micah 6:8, as well as the same Bible used by George Washington at his 1789 inauguration. This was the last inauguration to take place at the East Portico of the US Capitol. (LC.)

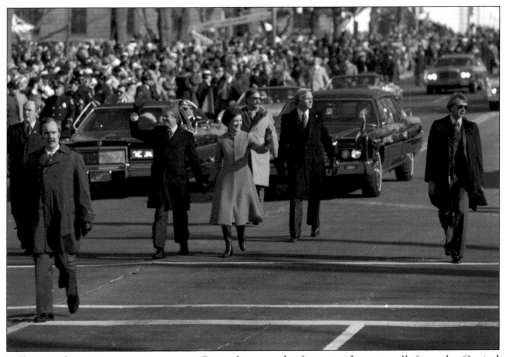

Following the swearing-in ceremony, Carter became the first president to walk from the Capitol to the Executive Mansion in the inaugural parade. The simple act severely stretched the Secret Service as the First Family walked the entire route. Today, the newly inaugurated president only walks one section of the parade route. (LC.)

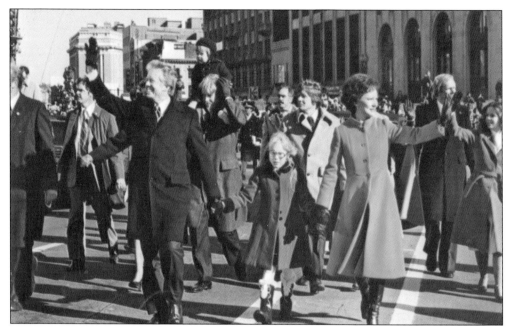

In 1977, Jimmy Carter started a tradition that has now become one of the most anticipated events on inauguration day. While in the motorcade of the inaugural parade, Jimmy and Rosalynn Carter exited their car to walk the route to the White House. Only the Secret Service had been notified of Carter's decision to break with tradition. At first, parade viewers thought the car had broken down. (AC.)

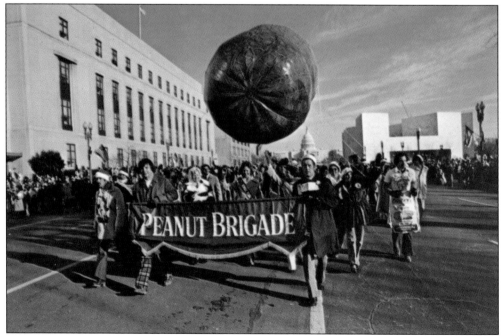

Here, some Peanut Brigade volunteers take part in the inaugural parade. One man is visibly wearing several sacks with the Carter Company's logo, while other members carry a giant helium-filled peanut. (AC.)

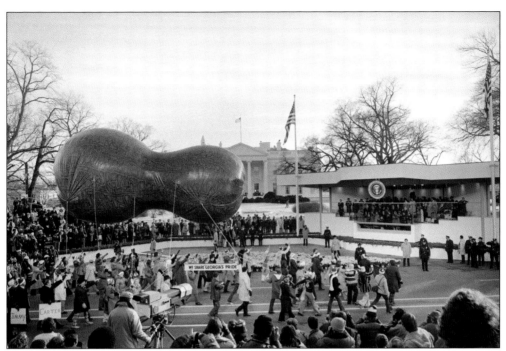

At the request of President Carter, there were fewer grandstands so that more citizens could line the parade route. This resulted in thousands arriving early to witness the 31 floats and 55 bands that made up the parade. (LC.)

The organizers of the event wanted to honor the new president's Southern roots and designed an elaborate float that looked like the exterior of the Grand Ole Opry. It included a live rooster on top of the building attached to a support cable. Toward the end of the parade, the rooster grew restless and accidentally hung himself on the cable. (LC.)

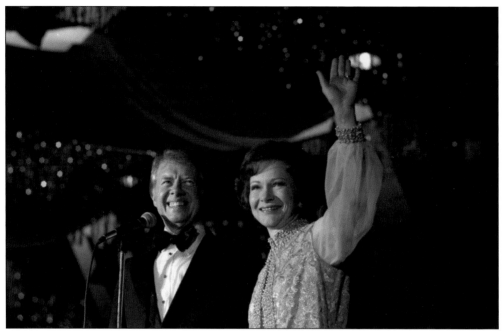

The president and First Lady wave to well-wishers at an inaugural ball. Originally, six parties were held at various locations in the capital city on inauguration night. But, due to the large crowds expected to flood the capital, a seventh was quickly added to the listing. Anyone connected to the Carters or the city of Plains was in high demand that evening. (LC.)

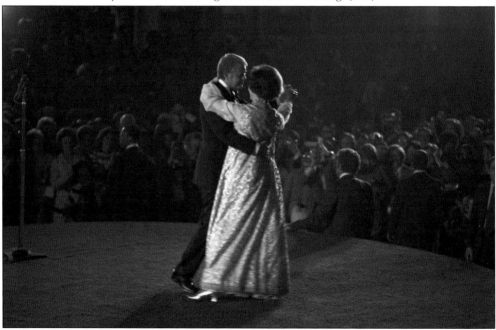

"Is anybody here from Georgia?" the new president asked one crowd. Vice President Mondale proclaimed at another event, "I'll tell you one thing—Washington, DC, is now Georgia country." As the president entered each ball, his campaign song, "Why Not the Best?," was played instead of the traditional "Hail to the Chief." (LC.)

This is an official photograph portrait of First Lady Rosalynn Carter. The floral arrangement in the background was perhaps one arranged by the Plains Garden Club. The club went to Washington in January 1977 to decorate the public rooms of the White House. Ann Dodson, who owned a beauty parlor in downtown Plains, served as chair for the group's White House Decorating Committee. (LC.)

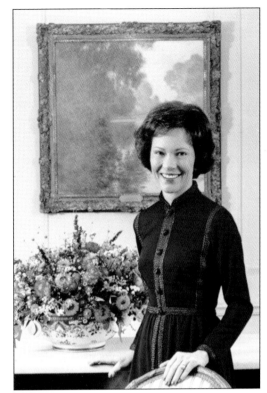

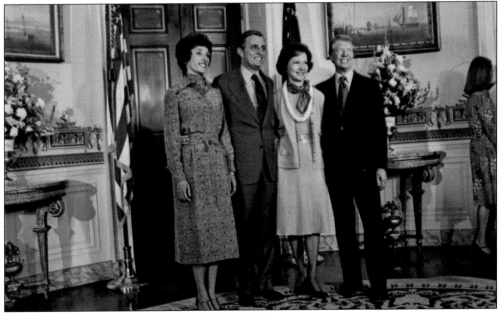

Seen here are, from left to right, Joan Mondale, Vice Pres. Walter Mondale, Rosalynn Carter, and Pres. Jimmy Carter during their first day on the job. They are greeting thousands of supporters in the traditional post-inaugural open house. This event was memorable for a number of reasons. Amy Carter and several friends from Plains took over the house's residency floor, and South Georgia folks rubbed shoulders with members of the Vanderbilt family. (AC.)

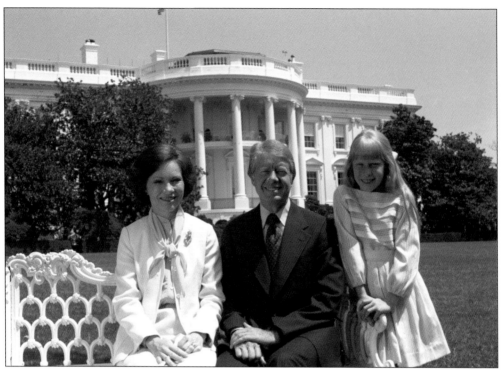

The Carters were the first family since the Kennedys to bring a young child with them into the White House. Jimmy and Rosalynn went to great pains to ensure that young Amy would not be isolated, placing her in a public school. (JCL.)

Amy Carter, seen here in her bedroom, was the subject of intense media scrutiny during the four years she lived in the White House. Many reporters and columnists remarked that she looked bored and morose during public functions. She would frequently read books during White House receptions or spend her free time away from the public areas of the White House. (LC.)

On inauguration day morning, as the Carters' belongings were transported from Blair House to the White House, it fell to one Executive Mansion butler to transport Amy Carter's pet cat. By his own admission, the butler was not a cat person. He remembers vividly how the scared animal clawed his overcoat during the brief move. (LC.)

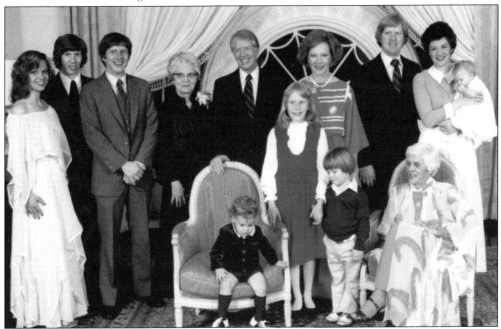

President Carter poses with the nation's First Family. Shown are, from left to right, Annette Carter, Jeff Carter, Chip Carter, Allie Smith (the president's mother-in-law), James Earl Carter IV (seated), Jimmy Carter, Amy Carter, Rosalynn Carter, Jack and Judy Carter, Sarah and Jason Carter, and Miss Lillian (seated, far right). Both Miss Lillian and Miss Smith stayed frequently at the White House, while the Carters' grandson James Earl IV was actually born in the mansion. (LC.)

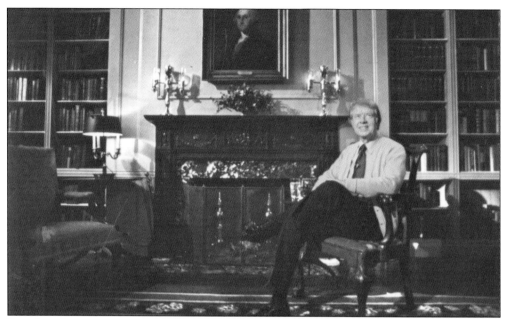

President Carter prepares to hold his first White House "fireside chat." Carter dressed modestly in a cardigan sweater. This simple change of apparel was a huge departure from the suit-clad Oval Office addresses of his predecessors. One of these cardigans is now on display at Carter's presidential library. (AC.)

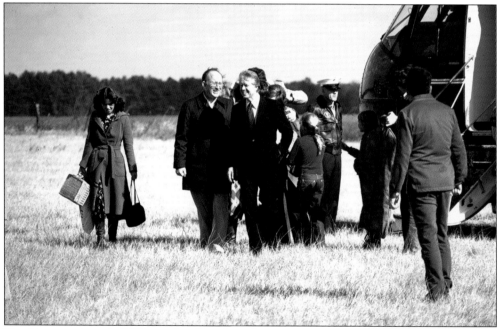

The big news in early 1977 was that President Carter was returning home for a brief vacation and that the town was getting its own red light. "Plains has arrived" was the proclamation from many townsfolk the day the light was installed at the intersection of Bond and Church Streets. Many in town could not decide what was more important, the homecoming of the president or the new light. (Charles W. Plant.)

All First Ladies have office space and staffs located in the East Wing of the White House. First Lady Carter used both and became particularly active in the area of mental health, a cause she is still deeply involved in. She was so engrossed in all areas of her husband's administration that he invited her to attend cabinet meetings. (JCL.)

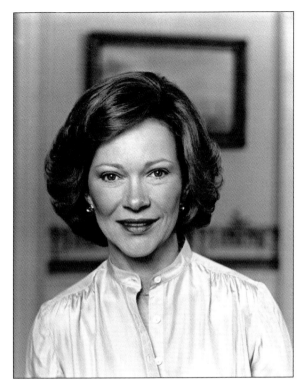

In July 1977, the Falls City Brewing Company produced Billy Beer. Each can carried his endorsement and signature: "I had this beer brewed up just for me. I think it's the best I ever tasted. And I've tasted a lot. I think you'll like it, too." (Charles W. Plant.)

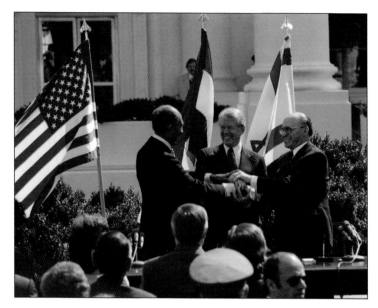

President Carter stands with Pres. Anwar Sadat (left) of Egypt and Prime Minister Menachem Begin (right) of Israel. Carter's tenure as president included both triumphs and tragedies. He came into office with a large amount of political capital and spent a good deal of it early on the Panama Canal treaties. The Camp David Accords, however, are often seen as his administration's high-water mark. (JCL.)

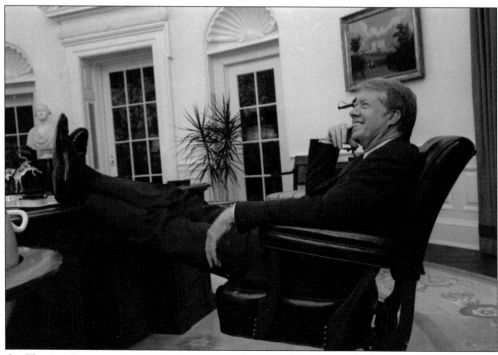

On Election Day morning 1980, all the networks carried footage of the Carters voting across the street from the railroad depot. Jimmy Carter had, four years earlier, traveled to that same spot to welcome in a new day and a new chapter in his life. Now, he was traveling back to the White House after his pollster informed him he would lose the election by 10 points. (LC.)

Five

A NATIONAL PARK

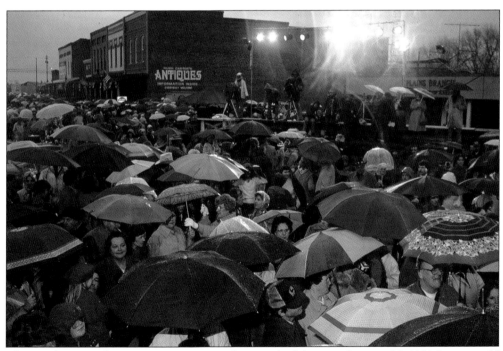

Thousands jammed Main Street as Marine One touched down on January 20, 1981. It was a cold and rainy day in Plains, one of the only Carter homecomings in which it rained. Despite the somber setting, the community came out in full force to welcome back the Carters, putting out what Maxine Reese called "the world's largest covered-dish dinner." (Charles W. Plant.)

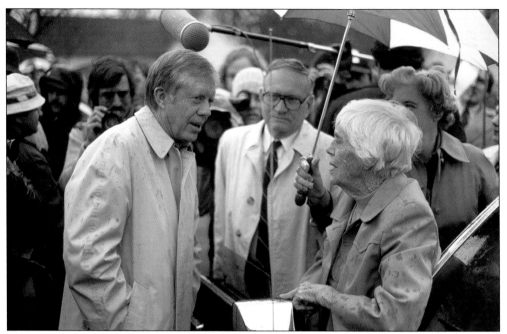

The Carters traveled to visit Miss Lillian before going back to Washington on the eve of his election-night defeat. There, the president informed his mother of the grim news that he would soon be defeated. Her reply was a stubborn acceptance of the electoral outcome, claiming that she was ready for life to get back to normal. (Charles W. Plant.)

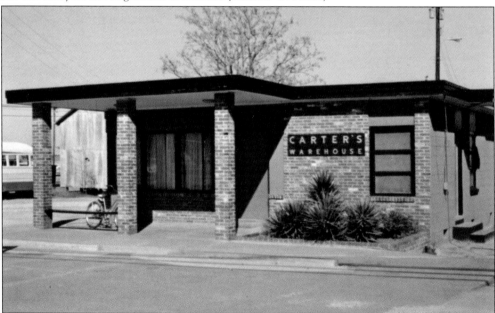

Upon entering the presidency in 1977, the Carters placed the management of the Carter Warehouse in the hands of a blind trust. This was done so there would be no hint of the new president using his position for financial gain. When Carter left office, it was discovered that the business was severely in debt. As a result, the former president had little choice but to sell his beloved business. (AC.)

The Carters stand outside of the Maranatha Baptist Church. The former First Family moved their membership to this congregation following their return from Washington, DC. They had previously worshipped at the Plains Baptist Church but switched their membership after the 1976 election. Jimmy Carter teaches Sunday school two or three times a month to packed houses. (Charles W. Plant.)

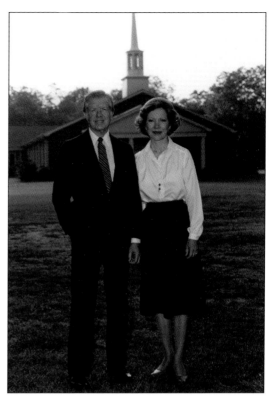

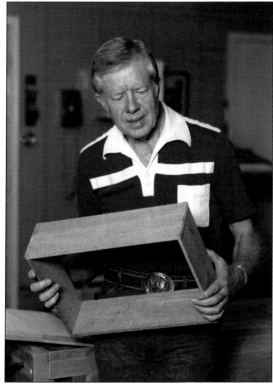

During President Carter's final weeks in office, the entire Carter cabinet surprised him with a departing gift: an array of tools and machinery so that he could start his own woodworking shop in his home. The former president and his son Chip transformed the family's old garage into the much-used room. (Charles W. Plant.)

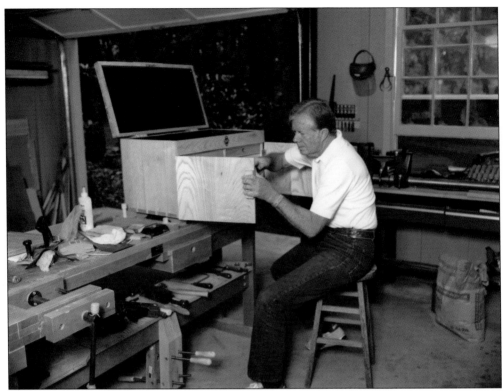

Not surprisingly, it was as a carpenter that Carter's reputation, briefly tarnished following his political defeat, began to improve. Since the early 1980s, Jimmy Carter has donated his time and his talents as a carpenter to the charitable group Habitat for Humanity. Founded in Americus, Georgia, in 1976, Habitat has since become virtually inseparable from the postpresidential legacy of Jimmy Carter. (Charles W. Plant.)

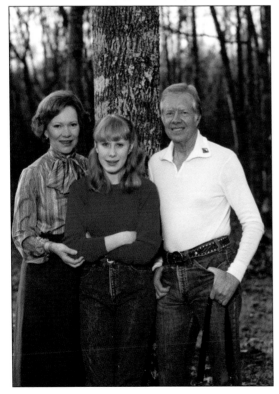

Rosalynn, Amy, and Jimmy Carter pose for a photograph during Amy's 16th birthday party in Plains. Upon leaving the White House in 1981, Amy proclaimed to her parents that she was no longer interested in living in the small community of Plains, having lived in the nation's capital. Eventually, Amy was allowed to go away to a boarding school, and the Carters, for the first time, became empty nesters. (Charles W. Plant.)

As a relatively young former president, Jimmy Carter rejected many opportunities to take commercial advantage of his position. He did plan on doing some lecturing, teaching, and becoming a full-time writer. He would go on to reject two offers to become a university professor. He was a praised guest lecturer at Emory University in Atlanta. (Charles W. Plant.)

As a former president, Carter was given an allowance for a secretary and office space. His transition team moved and processed countless official documents as they were prepared for storage. Miss Lillian spent most of her time at the pond house, so her home in Plains was used as President Carter's office in town. (Charles W. Plant.)

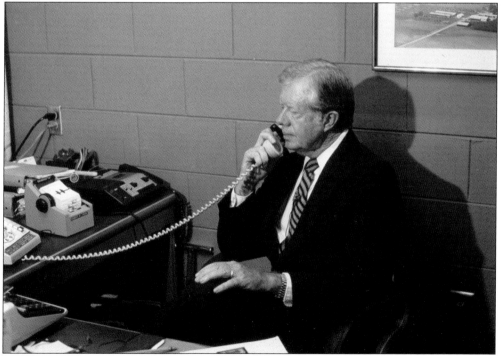

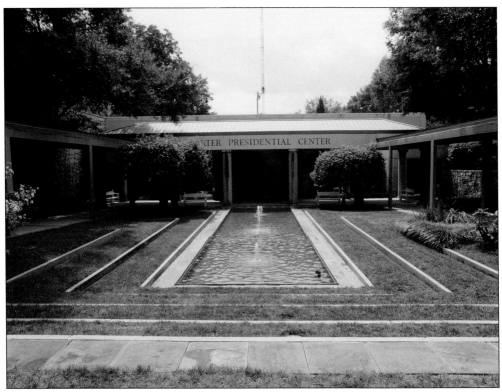

The main entrance of the Jimmy Carter Presidential Library and Museum is pictured above. The 69,750-square-foot structure is built in the Poncey-Highland neighborhood of Atlanta and on the same set of hills from which General Sherman observed the burning of the city. The site is also the home base of the Carter Center organization and the Carters' Atlanta apartment. (LC.)

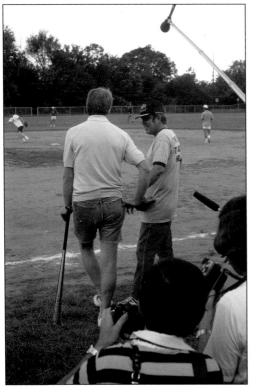

Billy Carter said, "I do not deny I brought most of my notoriety on myself, nor do I apologize for it." Billy, pictured here with his brother, was diagnosed with pancreatic cancer in the autumn of 1987, and he received unsuccessful treatments for the disease. He died in Plains the following year at the age of 51. President Carter's sister, and his father, James Earl Carter, both died of pancreatic cancer. (Charles W. Plant.)

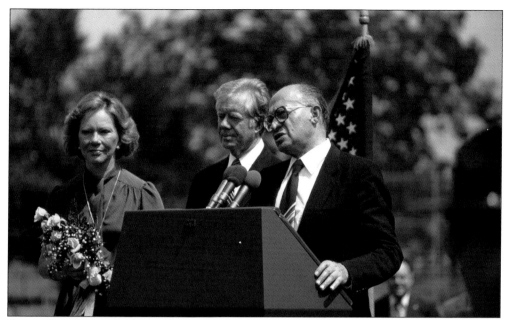

Despite having to rebuild much of his political reputation at home, the former president still enjoyed respect around the globe. Here, the former president and First Lady welcome Israel's prime minister, Menachem Begin, to Plains. They also played host to Egyptian president Anwar Sadat not long before he was assassinated. All foreign guests were shocked to discover that the former president did not own a helicopter and lived modestly. (Charles W. Plant.)

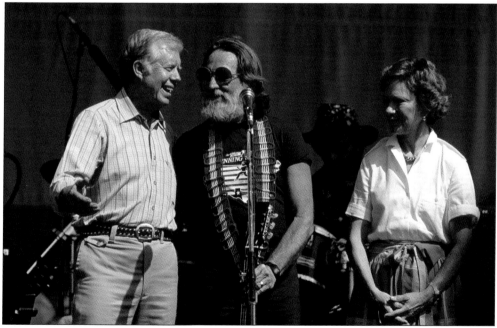

After leaving office, a former president has to fundraise to pay for the construction of his library and the permanent storage of his administration's documents. To make matters worse, Carter also had to pay off the primary debt he had accumulated following the Ted Kennedy challenge. Here, his friend Willie Nelson helps out, performing a benefit concert. (Charles W. Plant.)

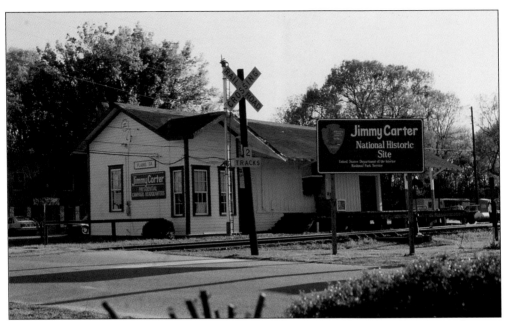

The National Park Service has restored the depot building to its 1976 appearance, and it now exhibits memorabilia from that campaign. The depot was chosen as the campaign headquarters because it was about the only building in town that had public restroom facilities. Today, it is a popular destination for tourists, as it houses countless items from the 1976 presidential election, including Miss Lillian's rocking chairs. (Charles W. Plant.)

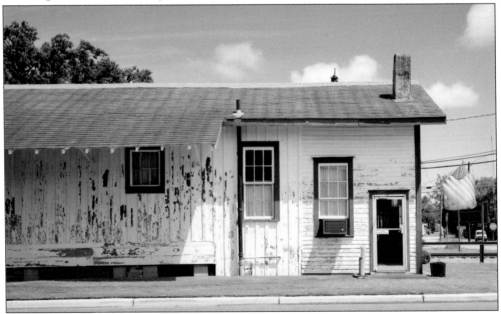

The Jimmy Carter National Historic Site and Preservation District was established by an act of Congress in 1987. The historic site includes the railroad depot, shown here in the early 1980s, when it had fallen into disrepair. The site also included the boyhood home, which needed to be purchased, and the Carter compound. The preservation district consists of the historic district and 650 acres of agricultural lands. (LC.)

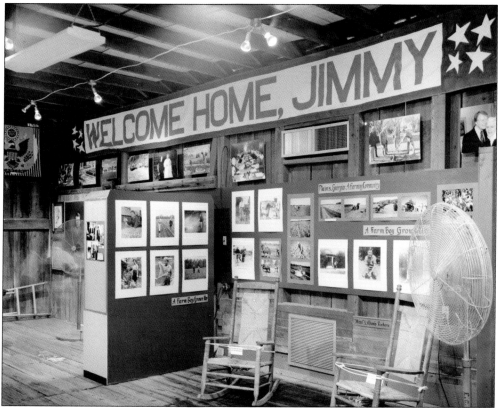

The interior of the train depot museum is seen here in the 1980s. Before the National Park Service became actively involved in preserving the town, the depot served as the town's visitor center. Today, it has interactive exhibits and detailed accounts of the 1976 election. At the time of this photograph, the citizens of Plains relied almost solely on their own personal memorabilia to fill the museum. (LC.)

Billy Carter's service station has always been an important part of the story of Plains. Like its namesake, it was a major draw and captured the public's imagination during the 1976 election. However, despite the facility's folk and populist appeal, there was always overwhelming hostility about including it in the national park. As a result, the Billy Carter Museum today is operated by the people of Plains. (LC.)

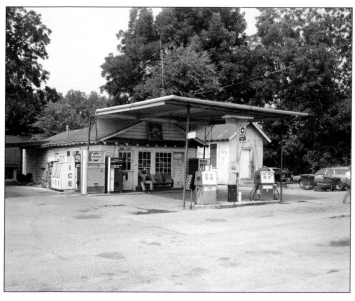

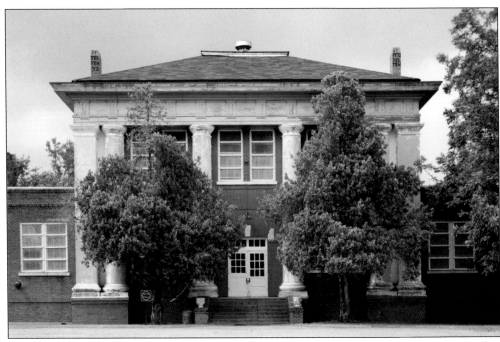

The Plains High School had long been left unused, but, as the US Park Service began its partnership with the town of Plains, many naturally looked toward the school as a prime candidate for restoration. The cost for repairing the partially dilapidated structure was $5 million. Community leaders like Maxine Reese, John Pope, and P.J. Wise worked tirelessly to acquire funding. However, federal laws required that 40 percent of the cost had to come from local sources. The entire community pitched in to raise the funds. The town hosted Willie Nelson again for a benefit concert, and there were square dances, bake sales, and contributions from alumni, and the Carters signed books and portions of boards from the schoolhouse. Today, Plains High School is the main visitors center for the historic site. (Both, LC.)

The family pond house was the site of many important gatherings, and it is where Miss Lillian spent her final years. In fact, it was the site of the famous $1-million fundraiser hosted by the National Democratic Party and where candidate Carter interviewed several potential vice presidential candidates. There was talk about including it in the national historic site, yet it remains private property. (LC.)

A major part of the Jimmy Carter National Historic Site is the Carter compound. It remains their private residence and is strictly closed to the public. It was donated by the Carters, and they have lifelong leases to reside in the home. A similar arrangement was made with the Johnsons in the 1970s. Following the death of Lady Bird Johnson, the property was opened as a national park. (LC.)

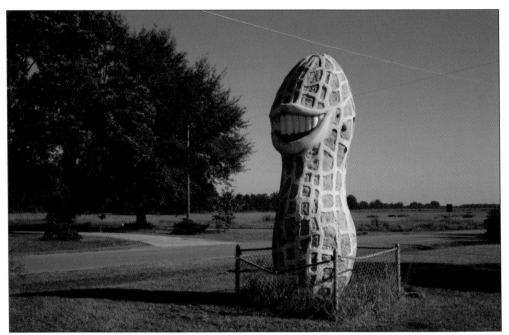

The Smiling Peanut is still proudly displayed in front of a convenience store, not far from the Plains Baptist Church. It is still a very popular location for tourists to take photographs and has been repaired by the city twice. The fence seen here surrounding the peanut has been removed. Today, the tourist attraction is encircled by a small hedge. (LC.)

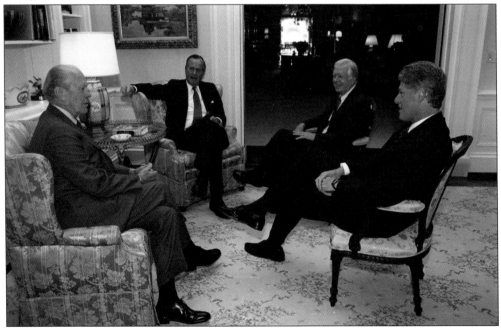

President Carter (second from right) is seen at the White House in 1993 with Presidents Ford (far left), George H.W. Bush (second from left), and Bill Clinton. President Carter's relations with many of his successors have, at times, been described as poor or icy. However, many presidential historians claim that Carter and Ford had the closest friendship of any two former presidents. (LC.)

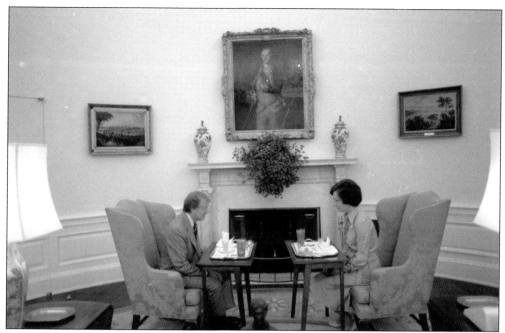

The Carters eat lunch together in the Oval Office. Upon leaving the White House, both Carters were deeply disappointed. Rosalynn, in particular, seemed openly frustrated by their electoral defeat in 1980 and, over the next few years, hoped for a rematch in 1984. But both Carters have since found great enjoyment in the postpresidential years. (LC.)

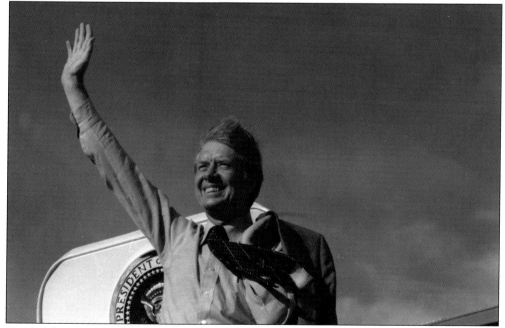

On October 11, 2002, President Carter accepted the prestigious Nobel Peace Prize from Main Street in Plains. Carter said, "People everywhere share the same dream of a caring international community that prevents war and oppression." One of the three small bronze Nobel medals Carter received is housed in the Plains High School. (LC.)

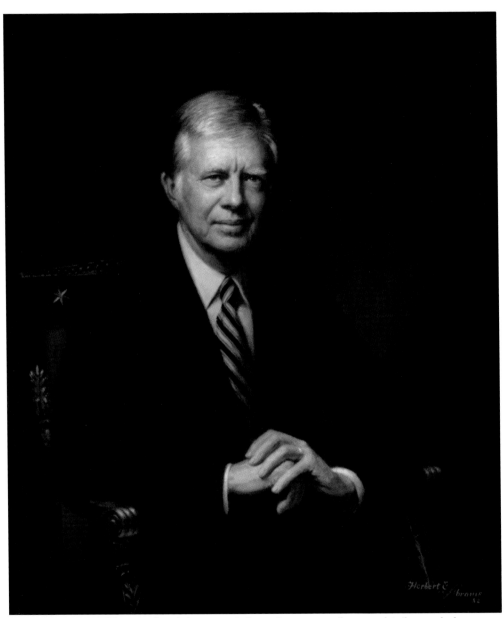

Jimmy Carter is widely considered the nation's finest former president, yet his four turbulent years in office continue to resonate with Americans, and his legacy can no longer be so neatly defined by his active life out of office. While Carter has gained a reputation for political ineptitude, in reality, his success rate with Congress was greater than that of his five successors combined. The simple fact is that his innovative agenda and honest manner seem to speak for themselves, while his humanitarian actions upon leaving office continue to make him relevant. (LC.)

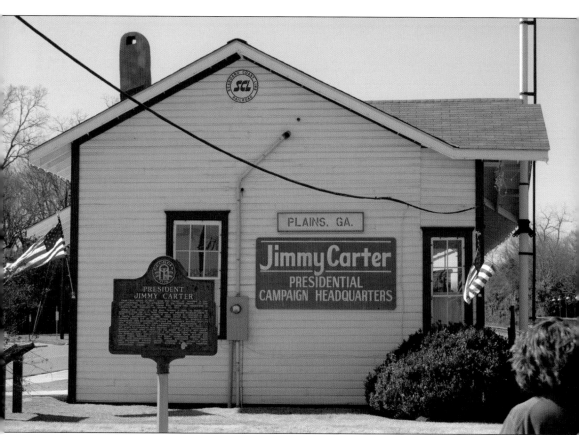

In 1986, the state of Georgia placed a historic marker outside of the depot. The plaque proudly proclaimed that the depot and its surrounding area symbolizes "the culture of this small rural community, which produced a highly respected international leader." Later that same year, Seaboard Air Line Railroad and CSX contributed the building and its surrounding property to the National Park Service. A $7-million refurbishing of the CSX railroad line between Cordele, Georgia, and Jimmy Carter's boyhood home was later authorized. Today, excursion trains bring numerous visitors into Plains, and the entire area has enjoyed an economic boost. In some small way, the spirit behind the Peanut Express and the hometown campaign continues to live in these new excursion trains. (LC.)

There is a mysterious pull to this tiny hamlet in South Georgia. It can only be experienced, and it continues to be by nearly 100,000 tourists annually. They come for different reasons and purposes. Many come with their children to hear President Carter's Sunday school lessons, so that the youngsters can one day tell their children that they saw an American president. Many come with a silent longing for simpler times and to experience the rural lifestyle of Carter's boyhood. For these reasons and many more, Plains remains America's hometown. (LC.)

ABOUT THE JIMMY CARTER NATIONAL HISTORIC SITE

Whether one is a Carter enthusiast, a researcher, or just curious how a small town influenced a young boy who would become the president of the most powerful nation in the world, odds are, one will find a visit to the Jimmy Carter National Historic Site interesting. The history and culture of this rural community offer a glimpse into why the Carters' ties to Plains, Georgia, have endured the stresses of public life yet remain as strong as they were decades ago. A visit to the site provides an opportunity to explore the historic resources and rural Southern culture that had an influence in molding the character and political policies of Jimmy Carter.

Discover Thousands of Local History Books
Featuring Millions of Vintage Images

Arcadia Publishing, the leading local history publisher in the United States, is committed to making history accessible and meaningful through publishing books that celebrate and preserve the heritage of America's people and places.

Find more books like this at
www.arcadiapublishing.com

Search for your hometown history, your old stomping grounds, and even your favorite sports team.

Consistent with our mission to preserve history on a local level, this book was printed in South Carolina on American-made paper and manufactured entirely in the United States. Products carrying the accredited Forest Stewardship Council (FSC) label are printed on 100 percent FSC-certified paper.

MADE IN THE